The Art of
Kintsugi

The Art of Kintsugi

Learning the
Japanese Craft of Beautiful Repair

Alexandra Kitty

SCHIFFER PUBLISHING

4880 Lower Valley Road • Atglen, PA 19310

Unless otherwise indicated, all photographs by Gerhard Greeve.
Photos on pages 11, 13, and 14 (top) courtesy of BachmannEckenstein JapaneseArt, Basel (**bachmanneckenstein.com**).
Photos on pages 17 (top right), 17 (bottom left), 30 (left), and 33 (top) courtesy of Iku Nishikawa (**kintsugioxford.com**).
Photos on pages 30 (right) and 29 (bottom left) courtesy of HiDe Ceramic Works (**hideart.com**) and Asami Muraoka.

Designed by Ashley Millhouse
Cover design by Brenda McCallum
Type set in Clarendon URW
ISBN: 978-0-7643-6054-1
Printed in China

Published by Schiffer Publishing, Ltd.
4880 Lower Valley Road
Atglen, PA 19310
Phone: (610) 593-1777; Fax: (610) 593-2002
E-mail: Info@schifferbooks.com
Web: www.schifferbooks.com

To my mother.

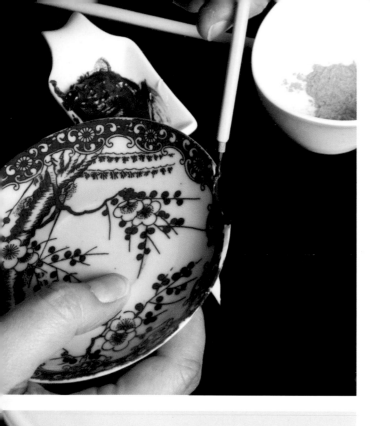
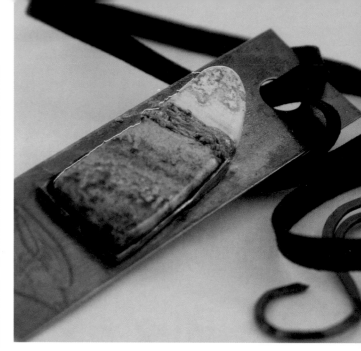

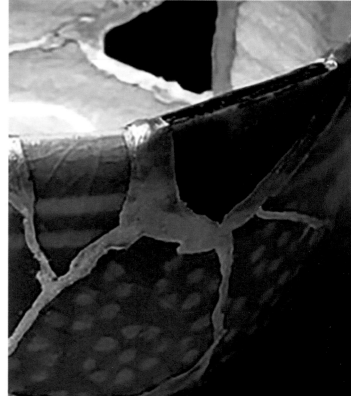

Contents

Preface

leaves in fall

are nice in all

my bird with wings of white

is a very pretty sight

my far journey away

it seems like a sad day

all my wishes

are like broken dishes

That was a poem I wrote in the fourth grade and promptly got a C on it. Worse, my teacher made fun of it in front of the entire class, who had a grand old time laughing at his prompting. The reason I got a C, he said, was that I had no idea what I was writing about and "kept changing the subject." It was a personal poem to me, and I did not appreciate the taunting, nor the assumption my teacher made.

After all, I knew exactly what I was writing about, and when I was in the eighth grade, I showed the same poem to my English teacher, who praised it and understood what I was expressing. Just as I suspected, we all have different ideas of what we like, and I decided not to take things so personally. What could have stayed a very traumatic experience for me turned out to be a great lesson for me, and I became a professional writer when I grew up.

I don't think about the poem a lot, but the last two lines came back to my memory once I began learning the art of kintsugi. Young Alexandra thought broken dishes meant the dramatic end of things, but the adult Alexandra discovered not only that broken dishes could be fused with gold to be restored, but that the dramatic new version was far superior to the original—and suddenly, a sad poem wasn't sad at all anymore. It was a *happy* beginning.

I realized kintsugi was an art of *defiance*: we choose our own ending by creating a *new beginning*.

And this book is about learning to find your new beginnings from the rubble of the past. We don't have to despair by the sound of crashing and shattering: we have an *opportunity* to do something with the broken to make them better than they were before.

So, when you begin your journey into kintsugi, remember that. Be good to yourself when you seemingly make an error. Kintsugi takes practice, but that's half the fun. Experiment and explore as you make your way from the pieces to a whole new beginning.

Alexandra Kitty

Broken Basics

CHAPTER 1:

A Kintsugi Primer

Kintsugi (金継ぎ) is an ancient and rare kind of art form originating in Japan. Kintsugi literally means "joining with gold" (and its practice is known as *kintsukuroi*, 金繕い), and it is one of the few art forms that stems from a philosophical belief. *No Mind* is the belief system that one does not get attached to things, and that we go with the flow because elements are naturally imperfect and impermanent.

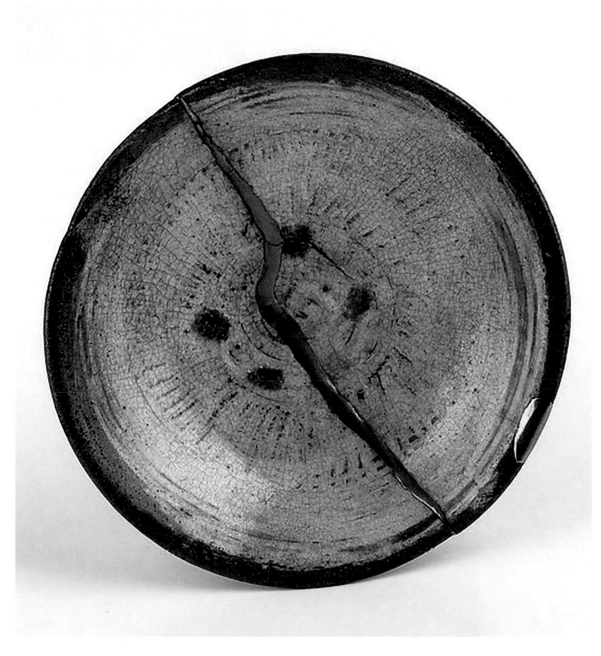

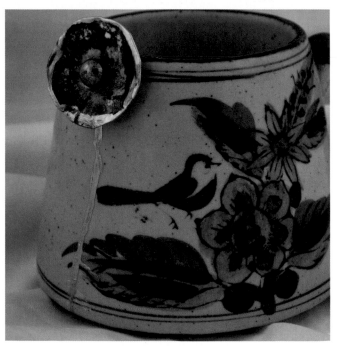

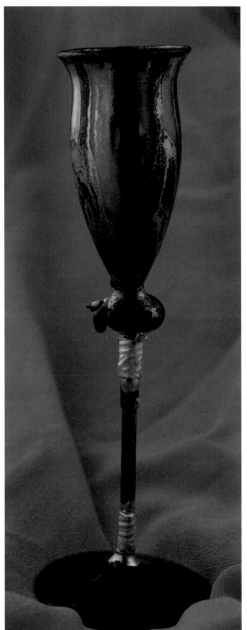

We are to live in the moment and accept life as we celebrate our flawed history. As those who practice kintsugi say, *broken is better than new.*

We can embrace history as we become proud of our imperfections and even *scars*. The mark of usage and wear is not to be hidden or a source of discomfort. It is not a source of shame or defect. We are not inferior because of those imperfections. It is the reality of our world, and we are to value the damage since it increases our own spiritual value: we survived, and while we may have been broken, the wisdom allows us to put ourselves back together. With that, there is no reason for fear, because the act of reconstruction makes us far more valuable than we were whole.

So powerful is the philosophical underpinnings of kintsugi that its process and beliefs have become accepted modern-day therapeutic treatments, though its applications go beyond spiritual healing, but to strengthening our own core beliefs of life in general. Psychologists are inspired by it, as are environmentalists, but it is the artists who have known all along the power of fusing the broken with noble metals. It creates a relationship between the artist and the piece to be resurrected.

Kintsugi takes that philosophy to *re-create* pieces. A broken vase, plate, or bowl isn't just repaired: it is repaired emphasizing the places that were cracked or chipped by using the precious metal of gold. It seems counterintuitive in modern culture, yet kintsugi has survived the centuries, with restored pieces surviving along with the art form.

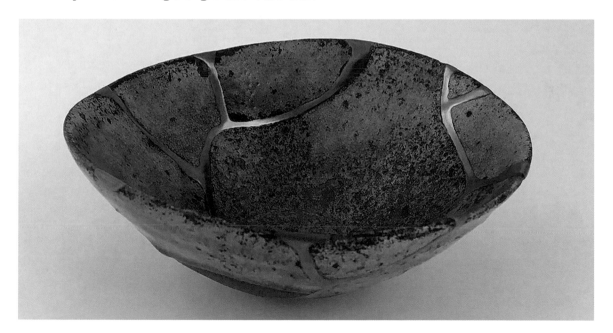

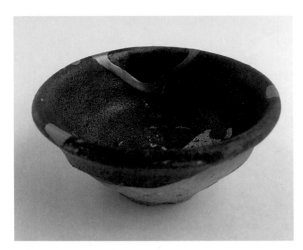

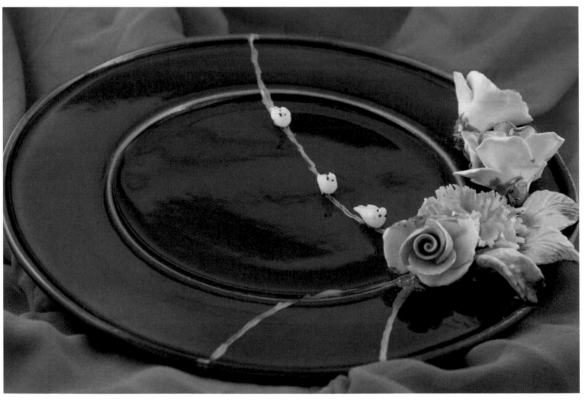

14

We can rebuild from a single broken piece, or we can combine from different objects to create a new one. This is the art of rebuilding and repairing and is seen as a *virtue*. It is an art with one of the most powerful and resilient beliefs: that we can triumph over *catastrophe*. It is a transformative repair, and the goal is to increase its aesthetic value to be better than when the object was new and unbroken.

But there is more to kintsugi than just repairing an object. When broken is better than new, we are not afraid of failing or taking risks. A broken vase is not be discarded; fusing it together shows that we cherish its place. Repair is merely a part of an object's history. In Western thought, repairs are to be hidden and flawlessness is revered, but kintsugi is the opposite philosophy. The object has a past, but we are confident that it also has a long future ahead as well.

We can take risks without worrying if things become broken, but we can also take artistic risks when putting those broken pieces back together. With serenity and acceptance comes creativity and bravery.

So, what is kintsugi?

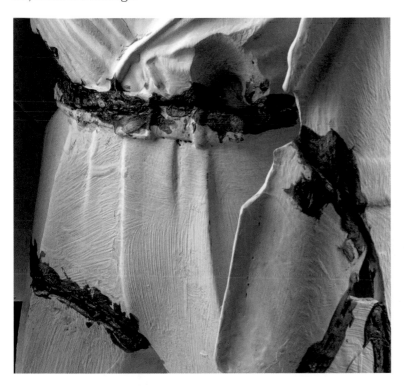
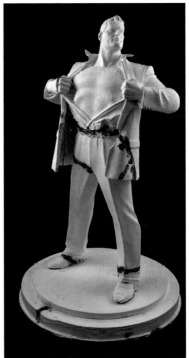

It is more than a mere ancient Japanese art form of restoration: it is a tangible philosophy of rebirth. It is the art form that confronts loss and destruction as it teaches its practitioners how to rebuild by using more valuable materials on those broken pieces. It is counterintuitive to Western sensibilities, but its practice has proven its peculiar logic to be in tune with our spirit and its strength as well as beauty. Kintsugi is the only art that has taken a spiritual philosophy as its very purpose.

It is a liberating creative philosophy. We do not have obstacles, but puzzles. With that, kintsugi shares the same philosophical core of the mythical practice of alchemy, where the goal is to take poor metals and turn them into noble ones such as gold, but unlike alchemy, kintsugi has tangible results to show for it. Kintsugi's underlying philosophy is having an empathy for objects, which is another shared trait with the royal art.

We do not skimp on our time, talent, or resources when we rebuild the past with the future in mind. We show respect for the past by honoring it and taking the time to work those pieces back together. While art takes discipline and practice, kintsugi is the art that encourages *spiritual* discipline and practice along with the physical one. It is unlike any other art form before it or currently.

For those who do not wish to part with family heirlooms or modern objects, this book is a portal to a new world of restoration: bowls, vases, plates, statues, and other ceramic and porcelain items have a chance at a new life, one where their value is far *greater* than before the fateful mishap. Chips, dents, and broken pieces are no barrier to bringing an object back to life; we place our own imprint on those objects as we embrace flaws and imperfections.

But kintsugi need not be relegated to traditional methods or use: creating new pieces and incorporating the methods into pictures, sculptures, and jewelry allow a new kind of creation where pieces from different objects are fused with gold to create textured and unpredictable work. While the use of broken plates in mosaics—known as *picassiette* (stolen plates)—is itself an art, it cannot be compared to the luxurious and therapeutic art of kintsugi. What has been broken apart can be restored whole.

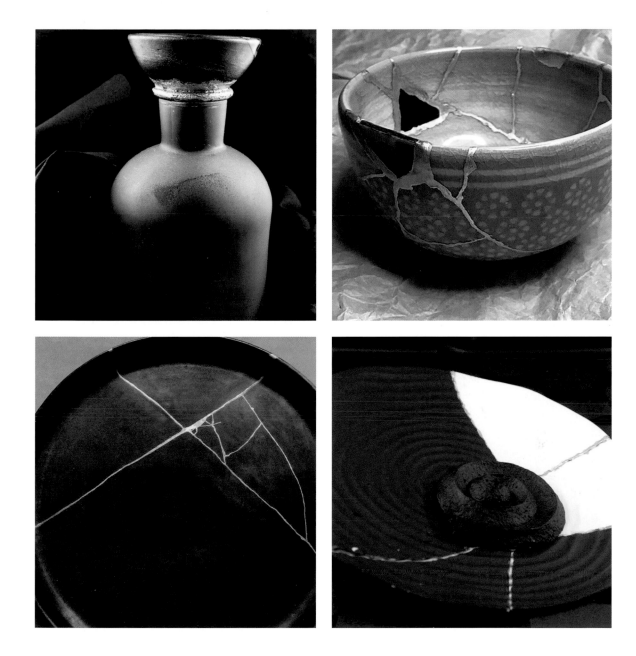

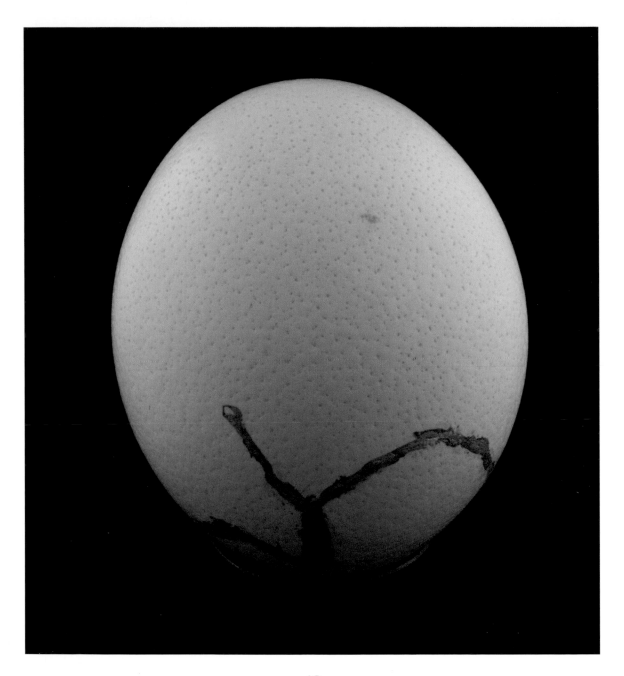

It is an art that also has one common thread with **art nouveau**, where mundane objects are viewed with an artistic purpose. While art nouveau turned dinnerware into art, it was designed with the purpose as it was made new, while kintsugi takes previously practical items and reinvents them into something more illustrious and valuable.

Kintsugi is an art that takes skill, patience, and care. It requires practice as well as honing your own technique. It is a versatile art form that is centuries old; we can merely repair a dish or a vase, or we can bring old statues to life. It is practical art with its own philosophy, and it is important to understand its core beliefs to better appreciate the techniques and purpose to get the most out of its practice.

This book will guide you through the process as well as the history and philosophy of kintsugi. It is an art that can be precise or imperfect in its execution but, despite it being an exercise in reconstruction, still allows individual expression and freedom to develop your own personal style and flourishes. Do not feel that you must not express your own uniqueness when you are putting back together broken pieces: the joy comes from the challenge of creating something better that is broken than what it was when it was whole.

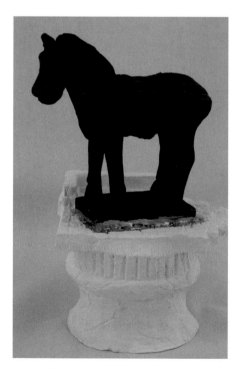

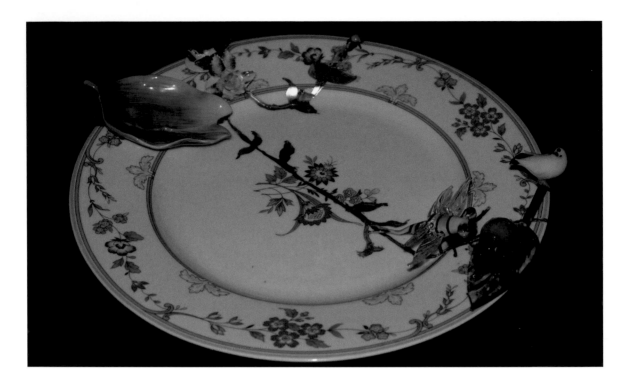

You will learn about the various forms of kintsugi as well as similar arts. You will discover various methods and techniques of assembly, drying, and presentation. You will become familiar with the tools and materials as well as the terminology of the art. How to reassemble bowls, plates, vases, pots, and even statues will be explored, as well as how to incorporate different ceramics to create something new and how to use kintsugi in other arts, from pictures to statues to even jewelry.

It is recommended that you acquire several "practice pieces" that you feel comfortable breaking, both to perfect and personalize your technique before you attempt to repair a piece you wish to fix. Learning how to master brushstrokes, gold powder application, assembly, and drying takes time, but the results are well worth it.

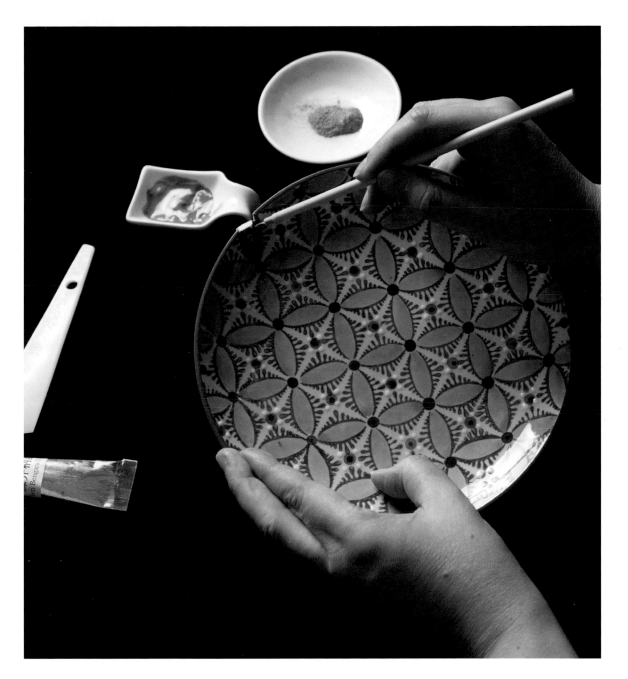

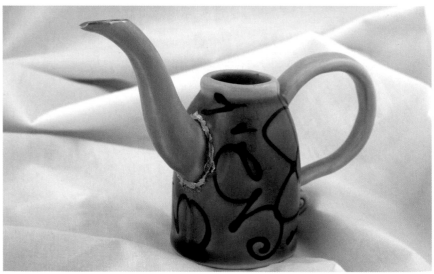

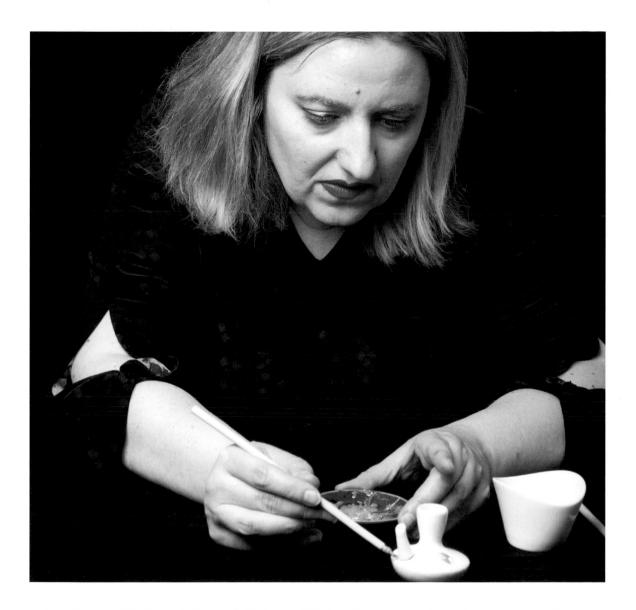

Let us begin with the origins and history of kintsugi, as we begin to immerse ourselves in a different world where imperfections are to be embraced and explored both artistically and philosophically.

CHAPTER 2:

A History of Kintsugi

To understand the origins of kintsugi, there are two concepts that we need to explore: first is the ancient lacquer *urushi*, and the second is the actual art of kintsugi and its evolution.

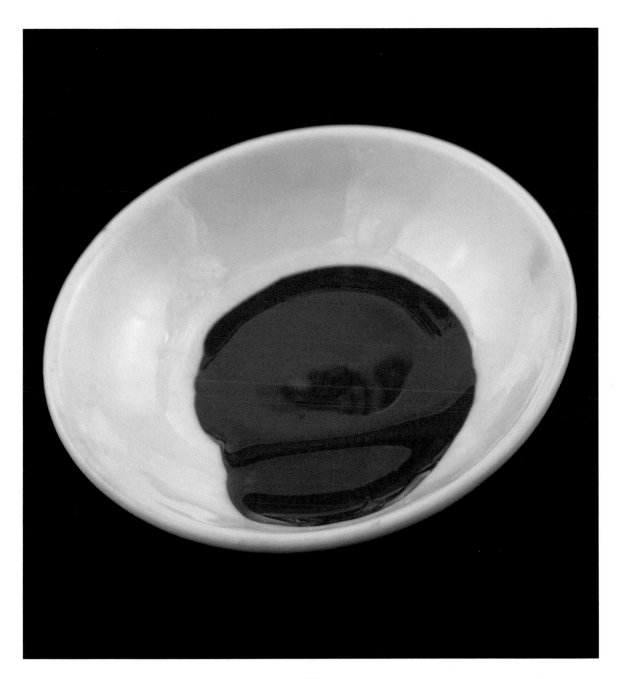

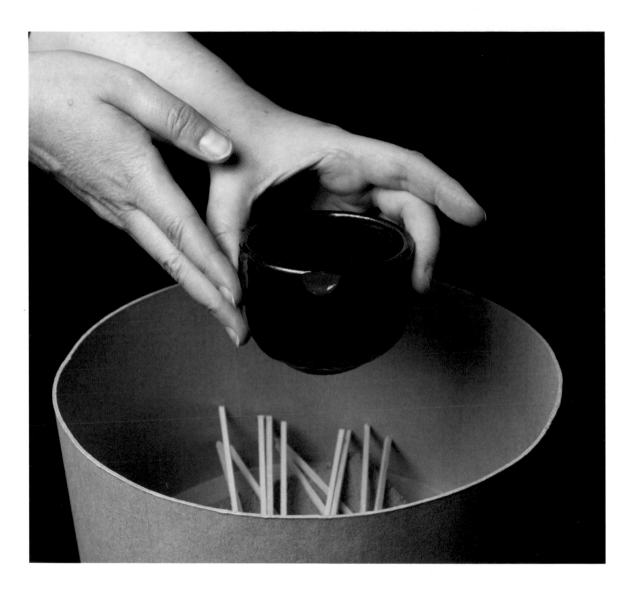

Urushi is a native Asian lacquer found in Japan, Korea, and China. It comes from the urushi (漆) or lacquer tree (*Toxicodendron vernicifluum*), and its sap has been used in lacquerware arts for roughly 9,000 years (though some claim it is a mere 5,000 years). This tree resin has many purposes, and Japanese lacquerware often has it without the use of gold powder.

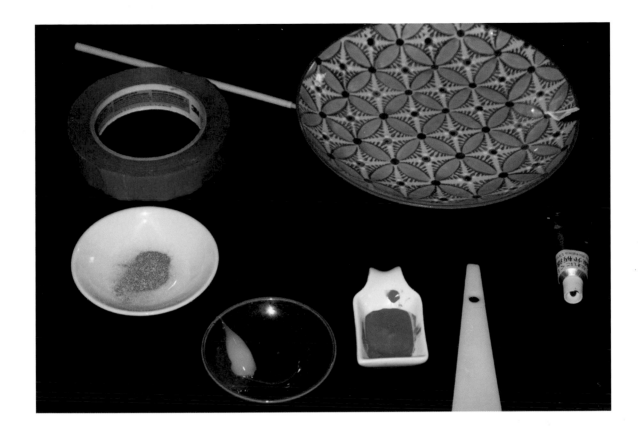

Urushi is used in many Japanese arts, including kintsugi. Urushi's purpose to add shine to the gold powder to give it its distinctive look. In another Japanese art, *maki-e*, urushi is painted on a wooden object, and gold powder is applied on top. The sheen makes the work unmistakable, and its origins go back as early as 794 CE, when it was a status symbol among the nation's court nobles and military elite.

But the art known as kintsugi had an illustrious if unusual origin: it began in the fifteenth century, when Ashikaga Yaoshimasa, a Japanese shogun, sent a damaged Chinese teabowl to China for repairs, and he was unhappy with the "ugly" staples that were used to put it back together. Hence, the shogun sparked a quest for more elegant methods of restoration.

Eventually, the idea came about to fuse broken objects with gold.

In other words, an unhappy customer became the inspiration for his own ingenious and unusual solution.

But there is another moral to the story: the staples used to hide the imperfections were unattractive. There was no hiding the flaw; hence, it was more attractive to draw attention to the flaw and make it stand out with a precious metal. This counterintuitive thinking sparked a new art form.

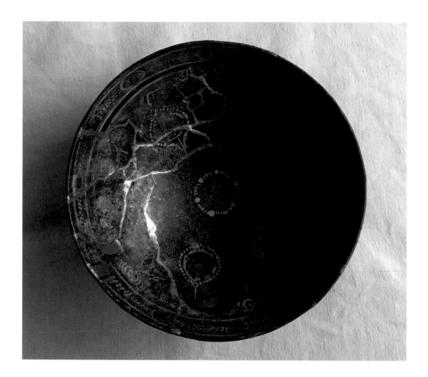

The idea to flaunt the flaws transformed the process of pottery restoration into an art form. This leap is not a minor consideration. Not only was a mundane service turned into a fine art, but it was guided by a philosophy that endures to this day. In Japan, one can obtain a university degree in kintsugi. It is an art, philosophy, but one where the medium is something that was created in its own right but now needs to be reconstructed. While kintsugi seems deceptively simple, understanding its nuances opens new methods of expression, and many therapists have encouraged victims of various traumas, from abuse to illness, to immerse in the art as a form of wellness and psychological healing.

However, there is more to kintsugi than its Zen philosophy or therapeutic benefits.

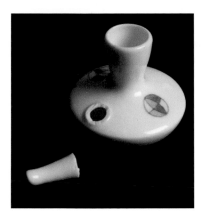 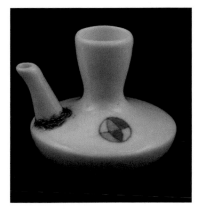

Throughout history, there have been several well-known artifacts that had been restored with kintsugi and are still intact, centuries later. For example, one 1904 Yamanaka & Company teabowl is part of the Smithsonian collection. Another nineteenth-century bowl is part of the Cooper Hewitt collection in New York City. From the Ethnological Museum in Berlin to the Tokyo National Museum, kintsugi has been a celebrated fine art globally, and while it is a distinctively Japanese art form, its beauty and timelessness know no cultural boundaries.

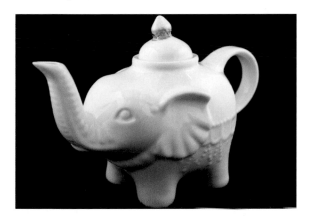

When five suspected kintsugi pieces were found at the historical Sleeper-McCann House in Gloucester, Massachusetts, the items were sent for analysis at the State University of New York for ultraviolet radiation, x-ray fluorescence spectroscopy, and Fourier-transform infrared spectroscopy before being declared genuine kintsugi-repaired artifacts.

East and West Notions of Beauty

For over 600 years, kintsugi has been the antidote to European notions of perfection. While European pottery emphasized uniformity and flawless complex design, Japanese teabowls were deliberately more rustic and simpler by their own creators' design. Kintsugi is an offshoot of that more textured look. It has been recounted that there have been collectors who were rumored to have deliberately broken their ceramics in order to have them restored with golden joinery. For example, one well-known seventeenth-century Japanese warrior who partook in the Way of Tea (known also as the tea ceremony or *chadō*) had been rumored to have bought inexpensive teabowls, deliberately breaking them, and then having them remade with kintsugi as a means of shrewd investment.

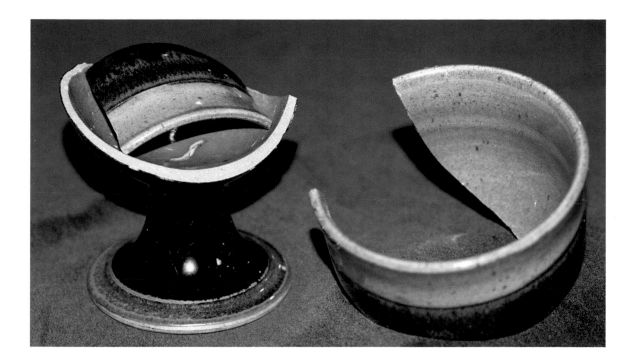

While kintsugi is a unique art form, there are similar techniques worth mentioning. Raden, for example, has its origins from around 710 CE, creating lacquerware of wooden and metal objects by using mother-of-pearl for its look. But if it uses urushi, its look and technique are completely different.

Maki-e has much in common with kintsugi in terms of primary materials of urushi and gold powder, but its purpose is not restoration, but beautification with design.

Picassiette is an art form of European origin (literally meaning "stolen plates") that also uses broken ceramics, but its intent is not reconstruction but to create mosaics using discarded objects. In that, it is similar to traditional mosaics, using grout rather than gold to fuse the pieces together.

Now that we understand the history of this ancient art form and know how it differs from other forms, let us take a close look at the philosophy that sparked its creation.

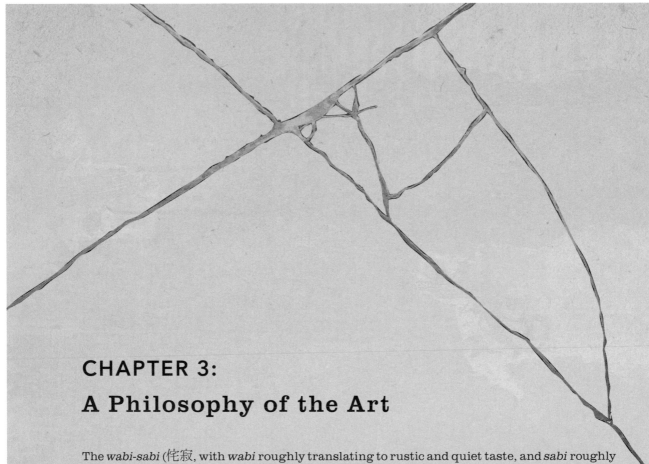

CHAPTER 3:

A Philosophy of the Art

The *wabi-sabi* (侘寂, with *wabi* roughly translating to rustic and quiet taste, and *sabi* roughly meaning loneliness or an exquisiteness that comes from maturity) philosophy is central to appreciating and understanding more than just the raison d'être of the art form, but also how you approach your objects as a practitioner. Kintsugi is a therapeutic art form for many reasons. First, a sentimental piece can be restored and not discarded, removing any distress or anxiety of losing what perhaps is the only object left of a departed loved one. Second, your ability to add to a piece's history and provenance builds your own inner confidence. Third, the cracks and breaks pose problems and often require lateral and creative thinking, meaning to solve the dilemma brings mastery and a sense of accomplishment.

But to those who do not know the ways of kintsugi, they merely see a bowl, plate, or vase with a gold vein and think it is part of the design. It is not design that brought the distinctive look, but the careful attention to reconstructing the piece with respect to its history and its place in someone's life.

Wabi-sabi means accepting the impermanence of life and our environment. Things are imperfect and asymmetrical, and we do not have closure, yet we accept this state of affairs without worry. It is a Buddhist teaching, and we can see it in much of Japanese culture, such as the simple, asymmetrical, and rustic look of ceremonial teabowls, and tea ceremonies. There is beauty in imperfection and there is much to celebrate around the concept. Kintsugi is an offshoot of *wabi-sabi* and is intimately linked with it; you cannot mention one without conjuring up the other.

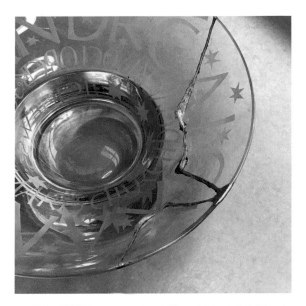

We carry no negative thoughts. We do not judge. We have no anger, fear, or hatred. We are grateful for the scars and do not try to hide them. There is no need for melancholy when there is wear and tear due to the passage of time. It is an optimistic philosophy and one of modest triumph.

Kintsugi is related is the Zen concept of *mushin* (無心), or the concept of No Mind: we do not form attachments to things, since they are impermanent and ever changing. We accept the fate of what has happened, but it does not mean we are victims of it. When we reach this state, we begin to understand and embrace our surroundings.

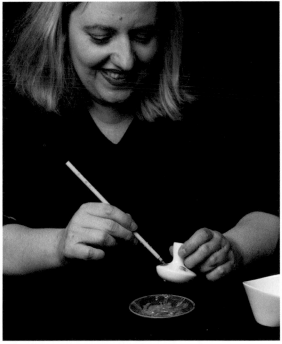

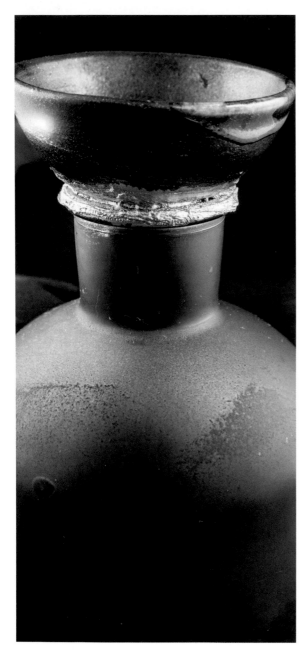

When we break an object, such as a plate or vase, often it is an accident that couldn't be helped, but often, it was broken because we were careless and distracted because we were upset, angry, sad, distressed, spiteful, or afraid. Our minds were elsewhere, causing clumsiness, and often, when an object shatters, we believe that is the end of it, and our unhappy state was punished by losing a cherished object. It is an unhappy ending, and one that brings us sorrow or more shame.

Other times, it is someone else's unhappy state that caused the destruction of the piece. We are no less unhappy about the outcome. We lost control of our own possessions, and now the ending is no less reassuring.

Kintsugi challenges those artificial boundaries. It is not the end, but a golden rebirth, and a new beginning after a transformation, or transmutation. If an unhappy state caused destruction, a calmer one can result in turning a sad turn into a triumph. We take our lesson and apply it to the destroyed object, rebuilding it and changing the ending. We have control, and we turn punishments into lessons. In a way, kintsugi is the practice of removing sorrow and negative distractions by rebuilding and giving attention to those items that we took for granted and neglected.

What the kintsugi artist does is making the most of broken pieces. It is a golden rebirth. We often regret that we cannot go back in time or turn back the clock, but with kintsugi, there is no need for

those sorrowful laments: we actively restore what was broken, and improve it as we add value to it. We study the broken object carefully, perhaps for the first time, after we owned it for decades. We see the smallest details and are reintroduced to a part of our past. Memories come back if it is our object we are repairing, or we are giving reassurance to others by bringing the object back to life.

When you practice kintsugi, what you are doing is overturning an unhappy fate. There are very few art forms that are imbued with a mandate of reassurance and control over the past. We take mundane objects and turn them into art. This singular sense of purpose should guide you when you are working with broken pieces. You have the power to turn sad and anxious feelings into happiness and relief.

But we have other considerations. We may be repairing someone's family heirloom. We may be repairing a piece with provenance. A vase may have been created by a well-known artist and then have been painted by another well-known artist.

Like other practitioners of kintsugi, the best way to perfect your technique is by breaking and repairing dishes. Finding old dishes at a Re-Store, at a flea market, or at "as is" sections at IKEA is an inexpensive way to practice. "Dollar store" plates and vases are of inferior quality and often disintegrate when broken and thus are not recommended to use.

Piecing Puzzles

CHAPTER 4:

Tools and Materials

Kintsugi is an art form that requires one central material, and several other smaller, yet still essential materials. Let us look at each category in turn.

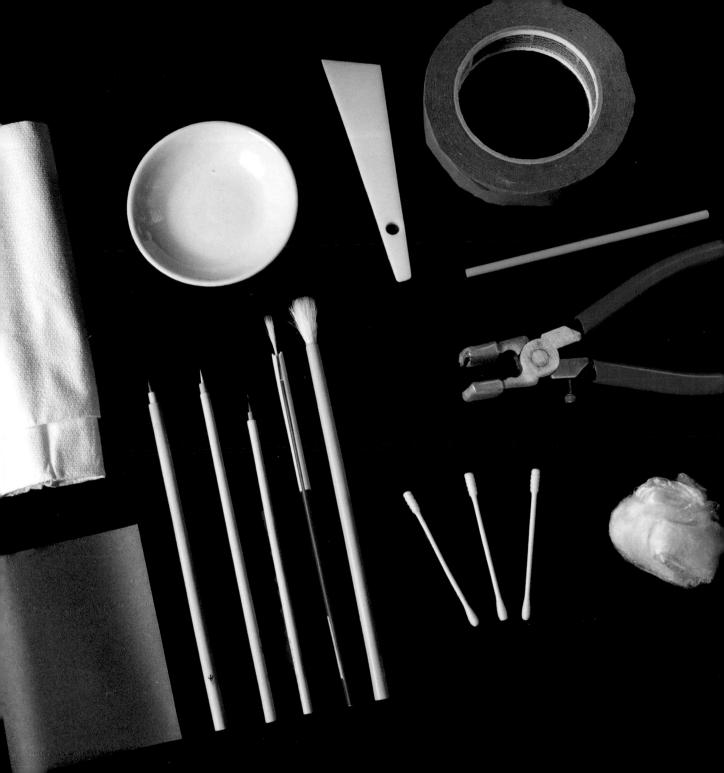

The central component is the broken object to be repaired, and this aspect ensures that every project is unique, meaning some ratios of materials will inevitably vary for each project. A small and delicate bowl requires far less material than a heavy tall vase, where gravity dictates more materials to ensure the object's stability post-repair. A crack requires less repair than a shattered piece. The broken object to be repaired is not the predictable element. Each piece will require careful examination and a plan.

Other times, kintsugi is one of several *elements* in an artistic piece. Here, too, each piece will dictate how to proceed to tackle your artistic vision. You may wish to electroform a small piece of ceramic with copper before electroplating it with gold, silver, or rhodium, adding visual texture and value to the piece. Sometimes, some pieces are too small to salvage, and you may wish to add other media such as wire mesh, beaded fabric, or some other nontraditional element, such as found objects, gemstones, or a resin mold.

Some ceramics are sturdy and forgiving, while other pieces are small and delicate and limit your choices in what you can incorporate. There are times where you may wish to fuse two separate objects together to add depth and texture. Once you have mastered traditional kintsugi, the possibilities may be endless, but the number of tools and materials required is relatively small and fixed.

How you must handle your pieces will also determine what tools and materials you will need. For example, a simple crack requires far less handling than a thin and shattered piece. You will want to be sure not to cut yourself or get a shard of a broken piece in your finger.

A Note about Resin Epoxy

An alternative to urushi and rice glue. Note that the use of non-urushi resins are often seen as "faux" kintsugi work. While curing times are faster with modern epoxy, with little chance of an allergic reaction, many collectors and artists will not recognize a work as kintsugi unless urushi is used in the process.

MATERIALS

rice glue: Literally a glue made from rice, which can either be purchased or made at home. For some pieces, this can serve as a preliminary step since it gives some leeway to repairing a piece prior to using urushi.

Note that if you opt to purchase rice glue (available readily in art supply stores or online), it does not require refrigeration.

For traditional kintsugi methods, it is the rice glue and urushi (*see below*) that serves as the adhesive; however, some nontraditionalists skip this step and use clear resin epoxy. Non-urushi resins are considered "faux" kintsugi, and we will focus on traditional pure kintsugi techniques.

How to Make Rice Glue

The recipe for rice glue is distilled water and rice starch powder, or sticky rice, such as sushi rice or basmati rice.

If you opt for rice starch powder, take 3 tablespoons in one cup of boiling water, stirring briskly until it is smooth with a yogurt-like consistency. Strain the lumps and let cool.

For thicker glue, use 4 tablespoons.

If you opt for the purist method, you will require three to four cups of distilled water, and one cup of sticky rice. Combine in a saucepan and bring to a boil. Lower the temperature and let it simmer for about forty-five minutes. If you have done this correctly, it has an oatmeal-like consistency.

Remove from heat and allow to cool thoroughly before pushing it through a sieve (or use a blender with water), then store in the refrigerator.

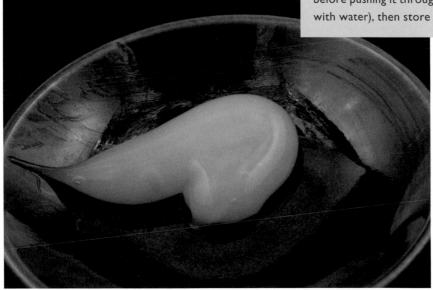

tonoko powder: Often, there is a chip that requires leveling, and this powder can be used before the lacquer and gold are applied. Tonoko powder is clay soil mixed with urushi to create a base filler for the chip to be repaired. It must be crushed and sifted before use. It is of a finer grain than *jinoko* powder.

jinoko powder: A coarser clay powder than tonoko that is used to fill chips

urushi: A high-quality lacquer that has been in use in Asia for over 5,000 years; it can be purchased in a variety of colors and is available with a shiny or matte finish. Urushi is slow to dry, and there are methods to hurry the process, but patience is still required. It is recommended that you wear gloves when using it, since some people can develop a rash from skin contact. Once it dries, the reactive nature is no longer a problem. There are low-allergenic urushi lacquers.

gold powder (and its substitutes): This creates the vein that beautifies the filling and restoration process. This is not paint, or gold leaf, which many imitation kintsugi pieces have.

Copper, bronze, and silver powder is also available and can be ordered online. Mica powder is available, as are other brands, but note that gold paint pigments are also considered faux kintsugi. While pigments are cost effective, the look will be different and easily recognized as faux kintsugi. Metal paints are also not legitimate kintsugi material.

When you are purchasing your gold for kintsugi, be careful of which powder you use. If you intend to use the plate, cup, chalice, bowl, or pitcher for consumption, be certain the powder indicates it can be used for those purposes. If the piece is decorative and not intended to serve food or drink, then you do not have to worry about the powder type.

gemstones: There will be times when you are missing a piece or wish to add a visual or textural twist to a piece, and one method of beautifying a piece is by using a semiprecious cabochon. Here, you have countless options, but there are a few stones to consider. For example, Persian turquoise is dense and has gold-colored veins that add a subtle layer of visual consistency to a piece.

Note that if you are introducing new pieces to your object to be repaired, the process is known as *yobitsugi*.

TOOLS

***kebo* brushes:** The most common paintbrushes in kintsugi are fine mouse- or mink-hair brushes; however, dog hair brushes are also available. The brush tip must be ultrafine if you are adhering to traditional and authentic kintsugi methods and look, but if you are deviating from the standard, wider and less precise brushstrokes achieve a different look that you may prefer.

files: Emory files and other finer-grade files are often needed to remove small chips from rough surfaces prior to reassembly and, after the piece is dried, to level the pieces.

nippers: There are times when you wish to incorporate another material, and using ceramic nippers allows you greater control. For example, you may wish to replace a small ceramic piece with precious-metal clay, sculpted to match the broken piece in question. While nippers are rarely needed for traditional kintsugi, if you are creating a more intricate piece, nippers can facilitate adding other media to fit in tight spaces.

cotton and cotton swabs: To remove excess glue or paint, it is advisable to be well stocked with both.

plastic scraper: A handy tool to remove excess putty, glue, or urushi

gloves: Rubber gloves are recommended to use, particularly since urushi can cause reactions.

painter's tape: An invaluable tool in holding pieces together until they cure, this is ideal for not gumming up pieces and can hold even heavy ceramics and large pieces. While you can use other kinds of adhesive strips, some may leave residue or, in some cases, remove paint from the piece or break already fragile pieces. Choose your tape carefully and do not leave taped pieces for prolonged periods of time in sunlight, or you may risk discoloration.

hammers: If you are breaking ceramics deliberately to reconstruct pieces, a rubber mallet and towel are sufficient for optimal control. A jeweler's planishing hammer can also be used, but you may end up with more chips than if you used a mallet. You may also wish to use a hammer to break up tonoko stones into fine powder when filling chips.

paper or plastic bags: This is to ensure that you do not lose any tonoko powder when refining it.

towel and box: When drying urushi, there are ways to speed up the process, such as an old towel, and a box (wood, plastic, Styrofoam) to keep the drying piece inside.

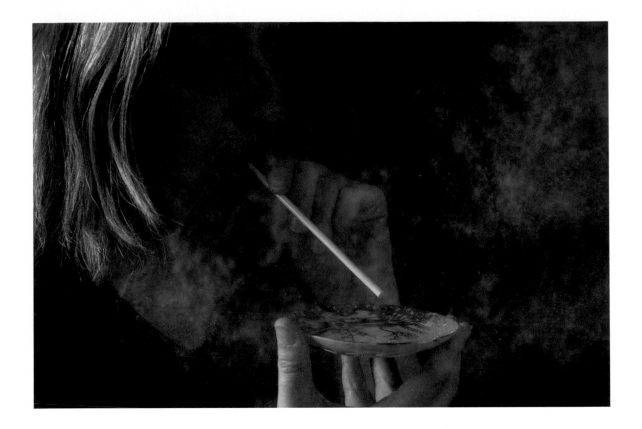

One final note: kintsugi, by its very purpose, creates uniqueness in every piece. No two kintsugi pieces can ever be alike. Each work is a one-of-a-kind piece that is asymmetrical and imperfect. Like Persian carpets, in which weavers deliberately put in an error as so to not offend the Creator, kintsugi's purpose is to celebrate and embrace imperfections. Each breakage or chip will be different, and as a kintsugi artist, it is important to understand the guiding philosophy of going with the flow. We are not to impose conformity but to let each piece speak to us, as well as study its imperfections before we reassemble it. We respect the original piece, but we are also leaving our own imprint on it as well.

Now that we are familiar with the materials and tools, it's useful to learn the language of the process before we begin making.

CHAPTER 5:

Terminology and Preparatory Practices

We understand now that this method has a long history and is based on embracing flaws. It is also important to know the traditional practices in order to maintain authenticity in your work with broken pieces.

Taking a look at the key terms and elements in the order presented below will help you understand how they will be guiding us throughout the kintsugi creation process. Understanding these terms will help your work be as authentic as possible. Particularly if you plan to sell your work in fine art or cultural venues, this is a benefit.

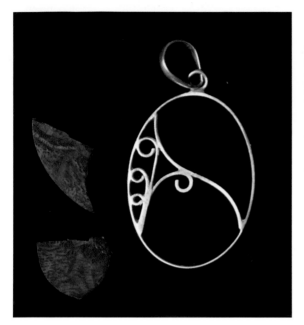 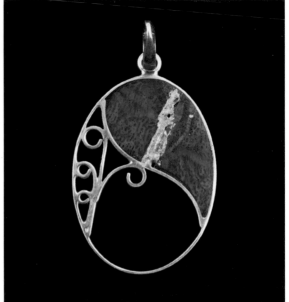

TERMINOLOGY

When we are dealing with the "imperfect" and the "destroyed," we understand that we cannot make a perfect replica of what a piece once was. There may be pieces missing. We may have more than one broken piece of pottery that would work better if combined. We may wish to incorporate other materials because they would enhance reconstruction.

Once we can embrace the concept of beauty in the scarred as we celebrate a piece's passage of time, the terms should be simpler to understand and embrace.

These are the core principles to think about first before we begin:

kintsugi (金継ぎ): Literally meaning "fusing with gold," it is the ancient art of restoring pottery with tree sap, rice glue, and gold powder.

urushi: This is a lacquer that has been in existence for thousands of years, and it is used in the restoration of ceramics, though it can be used to paint wood as well. It often takes weeks for it to dry when it's used in traditional kintsugi, but for the purist, it is a critical ingredient to maintaining authenticity of the method. Note that gloves are required when handling urushi, since many people of European heritage have an allergic reaction to it, though not everyone has issues with it. Once the lacquer dries, the chance for a reaction lessens.

mugi-urushi: Adding rice glue to urushi

suki-urushi: A transparent version of urushi

crack method: The simplest restoration method of reconstructing a piece using its original pieces (*see* tomosugi)

piece method: Identically replicating missing pieces like a puzzle and replacing the original piece with one made with urushi and gold powder. The most common and recognizable method of kintsugi (*see makienaoshi* method).

makienaoshi **method:** This is a restoration method that replaces missing pieces with gold.

On the other hand, the following concepts give us the ways to finesse the core concepts in kintsugi, since we view it as a puzzle of restoration:

muro **method:** Muro is the Japanese word for "closed." This method is a way to speed the process of drying urushi and will be discussed later on in the book.

staple method: This is a restoration method of drilling small holes to sew pieces together.

joint call: This method of restoration reassembles objects with similarly shaped pieces (*see* yobitsugi).

kintsukuroi (金繕い): Meaning to practice the art of kintsugi

tomosugi: Tomosugi involves using all of the original broken pieces for restoration.

yobitsugi: Yobitsugi involves introducing other pieces in restoration.

And finally, here are the final concepts to help us put the pieces of kintsugi together as a new whole:

tonoko powder: Clay that is smashed and added to urushi to create a putty to fill in cracks. It is finer than jinoko powder.

jinoko powder: A coarser grade of clay used with urushi to fill ceramic cracks

maki-e: The use of Japanese lacquer sprinkled with gold or silver powder with a kebo brush on items that may or may not be broken

mushin: The Zen concept of No Mind, where we accept life's impermanence and imperfections as we no longer become attached to the material

wabi-sabi: The philosophical underpinning of kintsugi that encourages us to see the beauty in the fleeting, imperfect, and enigmatic ways of life

BEFORE YOU BEGIN

Because the purpose of kintsugi is restoration, with the intent to see the beauty in flaws as we immerse ourselves with a serene and accepting mindset, we should prepare our work to fully benefit from a wabi-sabi philosophy.

Find a place where you can work uninterrupted and find peace. Natural lighting will allow you to see what work needs to be done, and fresh air will provide ventilation. Clean your surfaces, being careful to remove hair and fibers that could taint your work. A steady table with a large area is helpful for you to see each broken vessel, how you will reconstruct the piece, and the best method to use. Music in the background can help you find the right rhythm to work. Bring whatever things make your work easier—from a comfy sweater to your favorite beverage.

Ready to work on your first piece?

CHAPTER 6:
Techniques

Kintsugi is an art of exploration that weaves philosophy and history—both personal and collective—into a single piece. In its purest form, it is a restorative and historical art form. We respect the past, even if we are seeking to improve it. We reflect on how the past brought us to the present while we think about the future. Kintsugi's therapeutic value is in weaving spiritual *space*, and it reflects time in a different form. The joys of this unique and philosophical art are best experienced in a calm environment, and the simplest way to become comfortable with kintsugi is by taking our time by learning the basics and practicing its natural serenity. We are not competing with others, required to produce the most, or rushed for a deadline to find our worth; instead, we are learning our own value through finding the unrealized value of the broken pieces we are bringing together to form a new whole.

With kintsugi, no repair is too small or unimportant, so let us start at the most smallest of repairs and work our way to more complicated aspects.

BASIC KINTSUGI

Kintsugi is an art that is straightforward but requires patience and a balance of seeing how broken pieces can be put together to their original whole (tomosugi), or placed with different pieces to create something new (yobitsugi). Whether it is re-creation or reinvention, sometimes the repair is minor, and other times there are many shattered pieces from a large object to be put back together. We will begin with the simplest and the subtlest repairs before we take on more challenging projects.

Most people who know of kintsugi often believe that it strictly involves putting together broken pieces, but many times it is as simple as filling a small chip. This is the most basic of all kintsugi, and it is here where we will begin.

Filling cracks is a subtle aspect but nevertheless a staple of kintsugi repair. In this example, we will take a simple teacup and fill a small chip with gold.

A NOTE ON USING URUSHI

One of the most important considerations for you will be the kind of urushi you choose to use, since there are now a variety of options. There are matte and glossy urushi, and a variety of colors to choose from; however, some low-allergenic urushi are available, and there are those with shorter drying times. Cashew-based lacquers speed up the drying process but still require days to dry. It is important to find the right combination of factors when selecting your urushi; however, trial and error is required to find the one that will be your "universal" lacquer. Glossy traditional urushi is the standard for the purist. If you are trying to maintain authenticity to the original methods, stick with tradition. If you have more leeway, cashew-based lacquers will suit your needs.

HOW TO REPAIR A SIMPLE DENT OR CRACK

You will need rice glue, gold powder, tonoko powder, and urushi. Before you begin, inspect your piece and clean it.

Ensure that your workspace is cleaned, including your dishes, brushes, towels, swabs, and scrapers. Wear gloves to prevent the urushi from contacting your skin.

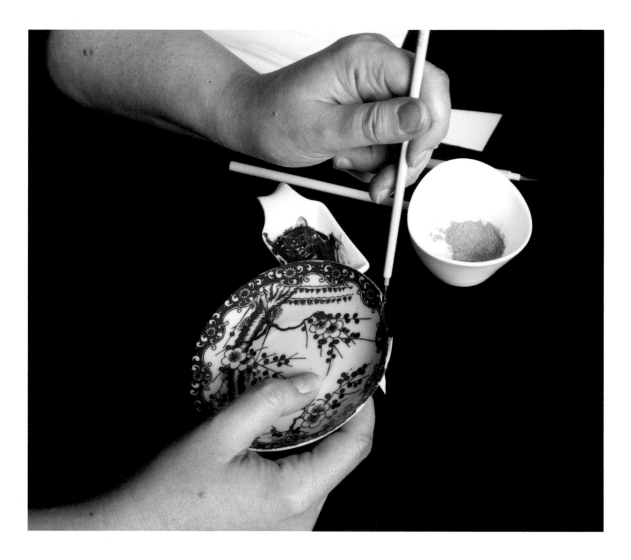

Examine the chip. You will need very little in terms of materials, but your most important material for chips is your chip filler.

Tonoko powder and the less common jinoko powder will come in chunks, and it is important to break these clay pieces into finer granules or flour. Take the clay and place a very small amount onto a plastic sheet or towel, then cover it. Use a mallet to break the pieces until they are fine.

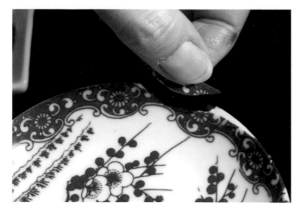

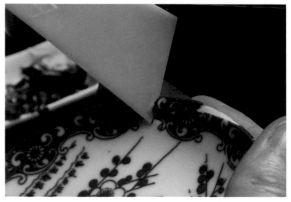

Add small amounts of distilled water and mix until the flour has turned into a spongy consistency.

Add a small amount of urushi and rice glue until you have mixed them together.

Use a fine brush to fill the gap with the mixture. Remove the excess with a damp cloth. Reclean your surface and let dry (see "The Muro Technique of Curing Finished Pieces," below).

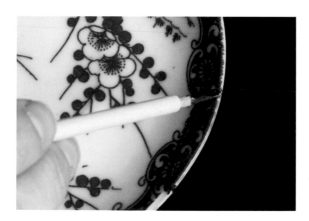

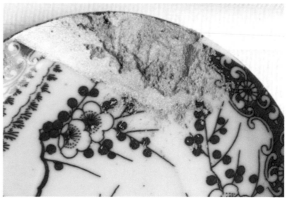

Once your piece has dried, add a thin coat of lacquer over your repaired area.

Sprinkle fine gold or metal powder over it. Let dry, using the muro technique.

Clean off excess gold.

Ensure the piece is to your expectations. Kintsugi is not about perfection, but it should be a piece that brings satisfaction. If you wish to finesse your piece or add other elements, you can build on a piece and redry it. A piece may take *months* to build to your vision; do not be afraid to rework a piece until it says what you wish to express.

CRACK METHOD

This is the simplest restoration method of reconstructing a vessel by using its original pieces and is the definition of tomosugi. What we have is a broken plate, bowl, or vase, and we have all the original pieces that we can put together. Often, kintsugi artists are asked to make the traditional repair by using the crack method, and for many amateur artists, this is their primary (and most times *only*) reason for learning kintsugi. A family heirloom has broken, and they wish to restore it the same way they found it.

If you are repairing a vessel for someone else, be sure to explain the process and ensure they understand the imperfect nature of kintsugi, and that metallic "veins" are part of the signature look. Do not be shy in explaining that the long process may take weeks, as well as the costs to be factored in. Clients may wish for finer veins or more rustic ones. Some will wish to use the piece for serving food, while others will not. Explain the differences in metallic powder types, so your client can make an informed choice. Establish their preferences prior to repair. Also explain that pieces should be hand-washed and not placed in the dishwasher. Finally, you may need to explain the difference between genuine kintsugi and its nonauthentic shortcuts. If you are striving for authenticity, it is best to steer away from the latter.

If you are doing the repair on your own piece, you have more leeway to experiment as well as change course to suit your own vision, and if you are creating pieces for artistic purposes, you must decide on the kind of urushi and metals you wish to use.

To use the crack method, you will need rice glue, gold powder, tonoko or jinoko powder, and urushi. Before you begin, inspect your piece and clean it. You will need brushes, a scraper, and painter's tape.

Ensure that your workspace, including your utensils, is free of dust and hair. As always, wear gloves to prevent the urushi from contacting your skin.

Examine the pieces and ensure that they can be placed in the proper order. Make certain there are no hairline fractures that may break later on. If there are chips, you can fill them in once your piece is restored.

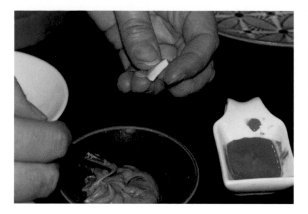

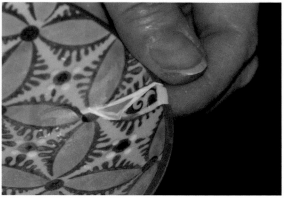

Mix your urushi and rice glue until they're consistent. If you are restoring a bowl or vase, start from the bottom and work your way up to the rim. If you are reconstructing a plate, start in the center.

Take two adjoining pieces and brush their sides with your mixture.

Press the sides together, aligning them. To secure them in place, you can use painter's tape to do so.

Take your scraper or a cotton swab to clean off any excess mixture.

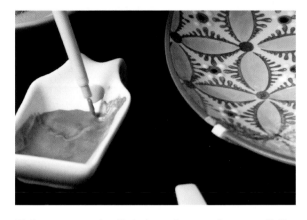

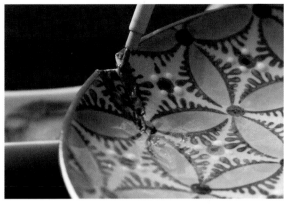

Take your next adjoining piece and secure it the same way.

Be sure to check on previously secured pieces to see if they are still properly aligned. Make any adjustments gently.

Continue until you have reassembled the piece.

If you have any chips, mix tonoko powder to your mixture and fill in the gaps.

Place your piece to dry. This will take several days.

Once your piece has dried, add a thin coat of lacquer over your repaired areas.

Sprinkle fine gold or metal powder over it. Let dry, using the muro technique.

Clean off excess gold.

Once you have completed your piece to your satisfaction, you may wish to keep a log of your process, especially in the beginning as you are learning the technique. It is a way to catalog successes and failures, as well as to keep track of any technique, style, or innovation you wish to reproduce or improve on as you become more proficient.

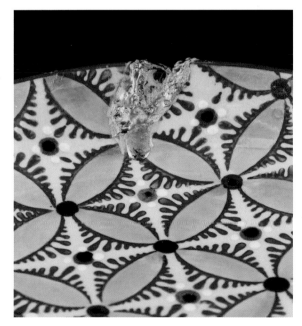

PIECE METHOD

Similar to the crack method is the piece method of replicating missing pieces by replacing the original piece with one made with urushi and gold powder. This is the most common and recognizable method of kintsugi, known as makienaoshi.

The steps are similar to traditional kintsugi, but here, you are re-creating missing pieces with urushi and glue, filling in the larger holes with the mixture of tonoko powder and urushi.

Making Missing Pieces

Often when there is breakage, we lose the entire piece. It is either lost or the fragments of a certain area are shattered beyond reconstruction. Other times, yobitsugi will give us uneven pieces of different vessels, and we are required to create our own pieces to fill the gaps. Finally, we may be inspired to replace a fragment with one of our own.

We have several options to fill in the blank, so to speak, and we will discuss nontraditional methods later on. For now, we will look at the traditional method of reconstructing pieces.

The method is similar to filling small cracks, but here, we have larger surfaces to cover.

Reconstruct your piece first, skipping any area that does not have a corresponding piece.

Ensure that your piece is aligned as you are gluing it with your mixture.

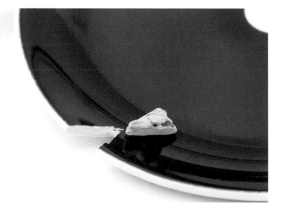

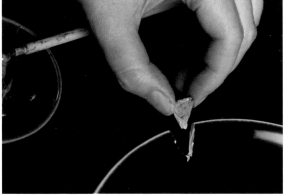

Once your piece has dried, go back and fill the area with your mixture of tonoko powder, urushi, and rice glue.

Scrape off any excess and work your mixture into the area from both sides of your piece.

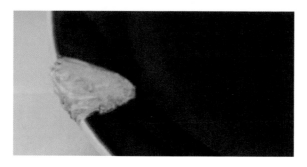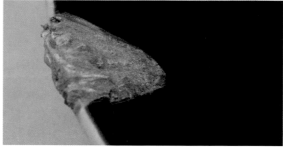

When you are finished, let the vessel dry. You may wish to create several muro boxes to accommodate different sizes of vessels, or to work on several pieces at once.

When your vessel has dried, cover the filled areas with urushi and sprinkle gold or other metallic powder, making certain you cover the entire area. Dry it when you are completed.

Clean off the excess gold powder.

Inspect the piece carefully to ensure you have taken care of the weaknesses of the broken or cracked areas.

JOINT CALL METHOD

This method, also known as yobitsugi, uses *similarly* shaped pieces from *other* pieces to re-create the piece. While new shapes can be formed with this method, we can also replace missing pieces with similar-shaped ceramics to create a more textured mosaic that maintains the original shape and integrity of the main piece.

The process is similar to the crack and the piece methods, with an added step of finding or creating replacement pieces that may be a perfect match, or similar, but smaller than the original.

If the piece is too small, it may be necessary to fill the holes with tonoko or jinoko after setting the piece. Alternately, you can use the piece method to add gold pieces to interlock.

You are not confined to ceramics or glass when using joint call method. Semiprecious stones will often fit into missing pieces and add an extra dimension to your work.

To restore by using joint call, clean your pieces and then decide which pieces you wish to replace.

Take care that the replacements are sturdy and thick enough to be flush with the original piece.

You may find it necessary to file down larger pieces to make a more manageable fit.

Use the same methods as above, substituting your new pieces as if they were original pieces.

Once the piece is assembled, use the same methods of curing and gold veining as the others.

If you are using the joint call method of someone else's piece, ensure you have explained how the piece will look, and if they have a certain replacement piece in mind, make certain the piece will fit and is not prone to breakage. If necessary, use painter's tape to make a crude reconstruction so the client has some idea of how the piece will look at fit-in.

STAPLE METHOD

One of the least well-known offshoot methods of kintsugi is the staple method. While it is beyond the scope of this book to show the method, what it important is that metal staples, usually brass, are used to hold the pieces together. This is a delicate process that requires drilling holes in the ceramic, then hammering each end of the brass staple into the ceramic. You do not need many staples, just placing them strategically in places. Urushi and gold powder are not required with this method.

A NOTE ON GLUING PIECES

While kintsugi creates durable pieces, the process of stabilizing your piece during its reconstruction is a delicate one. The gluing agents are organic in nature and are slow to cure, taking days, and, with large pieces, weeks.

Painter's tape keeps curing pieces in place without making any additional damage to the piece and does not leave a residue after removal. Be careful not to place tape over "wet" areas but carefully create a gap to go over your veins. If you are a beginner to the process, painter's tape will be a valuable asset to use, but once you are used to the delicate balance, you may find it unnecessary. Some artists use elastic bands to keep pieces in place, but if you are working with delicate pieces or small ones, there are disadvantages to it. As you gain skill, you may find an alternative that works for you.

With any form of kintsugi, more glue is not necessarily more secure. Be certain you cover the entire seam and align your pieces, scraping off any excess glue and using a damp swab or cloth to clean it. Once the glue is cured, the piece will stay secure. Do not try to "force" pieces into place; work carefully and gently as you align and balance your pieces together.

AN IMPORTANT NOTE ON WHAT IS NOT KINTSUGI

Often, it is tempting to cut corners and rush pieces by using shortcuts or hacks; however, kintsugi is a specific method of repair, and purists will consider any cheat a form of fraud. It is important not to try to cut steps or substitute nontraditional kintsugi materials into your work if you are working as a kintsugi artist. While there are many online resources purporting to show the art of kintsugi, most use epoxy and are not genuine versions of it. These methods negate the artistic spirit of kintsugi and are not as durable or well constructed as the authentic methods. The gold has a different and less vibrant look, often fades, and is missing many of the nuances of the originals.

Do not use any epoxy or glue as a substitute for urushi and rice glue. While it can take a couple of weeks for urushi to dry, a genuine kintsugi article uses no other form of bonding. Use genuine gold powder and not paint pigments or substitutes and ensure that the powder allows for use of the piece in food preparation, serving, or consumption after it has been cured if you are repairing plates, chalices, cups, bowls, or mugs. Finally, do not use clay filler as a substitute for tonoko powder to fill in cracks or crevices. While the piece may look the same as a traditional kintsugi piece, it is not an authentic piece, and the distinction is essential if are you declaring yourself to be a kintsugi artist.

If you are a professional artist or plan to sell your work as kintsugi, it is critical to be as authentic with your piece as you can. While you may develop your own style and use different tools to get the job done, the materials used to meld the pieces together are key to differentiating kintsugi from inauthentic versions of it. Do not compromise your reputation should a client who expected an authentic kintsugi repair is given an inferior version of it, and they discover it.

THE MURO TECHNIQUE OF CURING FINISHED PIECES

The muro technique is the standard method of "speed drying" urushi, which often takes weeks to cure.

Urushi requires high degree of humidity to cure. Levels of humidity should be over 75 percent but not over 90 percent, and the optimal temperature range is over 20 degrees Celsius or 68 degrees Fahrenheit. The simplest method of creating that environment is by making a "muro" box or cabinet.

A cardboard or Styrofoam box is ideal, though it must be big enough to hold the piece, with excess space, and be completely enclosed. On the bottom, place a sheet of plastic, then a *wet* towel. Finally, have a lattice of flat, wooden sticks to keep a barrier between the finished piece and the towel.

Place the finished piece inside your muro box and close the lid. Place the box in a secure place, and check every two days to see if your piece has cured, keeping the towel wet throughout the process. If the towel begins to dry, take a spray bottle of water and keep it moist. The more humid the box, the faster the urushi will cure.

Next we'll look at some specific types of objects to see the differences in reconstructing vessels with different kintsugi methods.

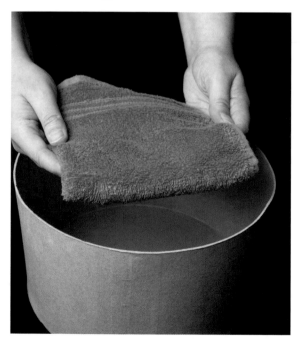

CHAPTER 7:

The Core of Kintsugi

While kintsugi's brilliance lies in its simplicity, there is much nuance and detail to explore. We will look at reconstructing the most common objects associated with the art—chalices, mugs, bowls, plates, and vases in this chapter—and stick with its traditional look before taking a look at how to use this art form as therapy. Each of these objects has its own unique properties, and we will consider how to take care when rebuilding each, using the various methods at our disposal.

CHALICE RECONSTRUCTION

Goblets and ceramic mugs have one main focus: if they are to be used to serve beverages, then their repair centers on using the proper gold powder and ensuring there are no holes left where leaks can occur. These are less important considerations when its original use no longer applies, but if this is not the case, your primary focus in on finding the holes and plugging them up.

This means we reinforce each piece and ensure it is aligned. We test our reconstructed piece, leaving water to test for seepage. Once we have test-run our piece, we can continue to add gold powder and complete the piece.

Chalices and mugs come in countless forms, but both have their own distinct shapes: chalices have stems, while mugs have handles. We will look at each one separately.

REPAIRING A MUG

Mug repair is a straightforward process, but if we are reattaching the handle, then securing it properly is key. If it is to be reused as a mug, the last thing we want is for the handle to fall off as the user drinks hot coffee or tea.

If you are using the joint call method and decide to use *another* handle from another piece, then you will need to follow these steps.

Measure the handle and the mug, making sure the handle can hold the weight of the mug and can align evenly for comfortable drinking.

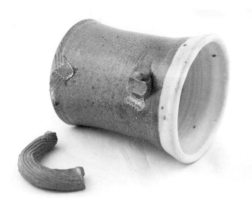

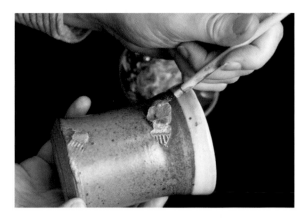

File the ends of both the handle and the mug, using a consistent upward motion. Do not file back and forth. File in a single direction to smooth the surface. A rotary tool makes the process go faster, but the ceramic will become hot to the touch and, in the case of fine delicate pieces, may crack.

When both ends are smooth, use your mixture of urushi and rice glue, painting them on with your brush.

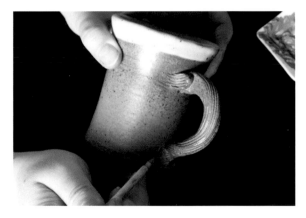

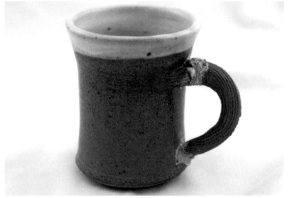

Join the pieces together, using painter's tape to keep them aligned and secure. Squeeze both parts together.

If you have other pieces to put together, carefully examine them to see if there are any hairline fractures or chips where liquid can escape. In that case, add tonoko powder to your mixture and fill in the holes, scraping off the excess and smoothing it.

Let the piece dry in a muro box or cabinet, and test for seepage. Check the strength of the bond between the handle and mug. If there are no additional repairs, add lacquer.

Sprinkle the metallic powder and return it to the box to dry.

Let dry, and wipe off excess powder.

If you are joining the original handle, it may also be necessary to file down both ends to make a more durable fit.

REPAIRING A CHALICE

If the chalice is to be reused as a drinking vessel, seepage is a more important consideration than if it is to become a more artistic piece. If the stem is shattered, it may be necessary to use the piece or the joint call method to reinforce the bottom. With goblets, balance of the piece is essential: a wobbly chalice will spill. If there are chips at the bottom, the simplest way to restore balance is by using tonoko powder to fill the cracks and chips.

Smoothing out the bottom and scraping off the excess allows the chalice to be more secure when it is standing.

Sometimes, we can "mix" a different stem with the joint call method. Like with the mug, it may be necessary to file down the connecting parts to maintain the balance and prevent future spillage.

Ensure that you test the piece after its first muro drying, to find any imbalance or seepage. For wobbly cups, you may be required to file the bottom. For leaking holes, adding tonoko powder will plug up anything that you missed the first time.

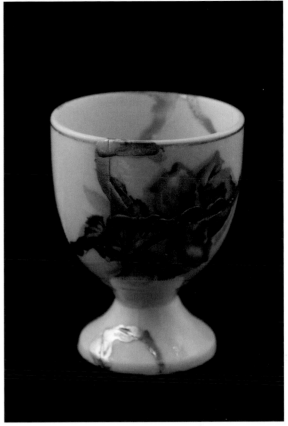

Egg holders are similar to goblets, only smaller. The method used to repair is similar, with the difference being that a water test is no necessary, since the object it holds is solid.

You may wish to "test" your egg holder by placing a plastic facsimile inside the holder to ensure it will fit in the vessel.

If you are repairing a candleholder, you may also wish to insert a candle to ensure a good fit that is not too tight or too loose—having a burning candle fall out of its holder is not something you'd want to happen. Taking small precautions ensures that your work is of solid and careful craftsmanship and, if you are repairing for others, lessens the chances of returns or refixing.

BOWL RECONSTRUCTION

Bowls hold a special place in kintsugi, since Japanese teabowls are revered for their rustic imperfections themselves. These are to be treated differently than more conventional "polished" ceramic or glass bowls when you are putting those unique pieces back together. While you have more leeway to create thicker and courser lines and pieces, including using the joint call method, be sure to study your piece to look at its own unique character to incorporate its own organic visuals with your own work.

If your teabowl is to be reused for its original purpose, ensure that you do a "leak test" after its first drying. Also ensure that the gold powder you use allows for consumption.

Study the piece carefully. Is it part of a set? If so, try to work with the piece. Do finer lines do it justice? Or coarser material? If there are any missing elements, consider using the piece method, since bowls of this ilk tend to be smaller.

If you are reconstructing a conventional bowl, its size and weight are critical considerations, as is function of the piece. A small soup bowl will be tackled differently than a large fruit bowl or punch bowl. Leakage may be an issue. Larger bowls used for food may require more drying supports and gold dust, the latter of which can become costly. If you are dealing with large bowls in many broken pieces, or missing pieces where you wish to use the piece method, you may need to factor your costs and make trade-offs.

When dealing with a bowl, balance may be a consideration if it is broken in the center in two or more pieces.

If there is a missing piece on the bottom, the joint call method may be your only option, and there are several factors to consider.

To create a piece, it will need to be a snug and flush fit. You may need to file a slightly larger piece to make the fit.

Alternately, using ceramic nippers or a tile cutter may be a more time-efficient alternative. If you are filing, be sure to wear a mask to prevent inhaling the dust.

The piece will need to be flat to create a sealed fit.

Fill the gaps with a tonoko powder mixture and do a water test once it finishes its first muro drying. Be certain to smooth off the excess with a scraper.

Larger pieces will require supports to dry. Use painter's tape and ensure the bowl is aligned.

Japanese teabowls are visually stunning when repaired using kintsugi. Another method of achieving the same rustic ends is by using potter's "seconds" that cost less than their top-grade piece, but their own imperfections are often beautified by using kintsugi.

PLATE RECONSTRUCTION

Plates vary in shape, thickness, and size but, unlike other vessels for kintsugi repair, allow more freedom and less worry regarding balance and leakage. Here, we can enhance imperfections without the same practical considerations other vessels pose to us. We are freer to use whatever method we choose, from the crack to the piece to the joint call methods.

Because they are flatter, they are easier to handle and piece together. If the plate is heavy or has many pieces to put together, you will need to secure each piece as you work.

Determine which method you will use. Will you incorporate other pieces into the work? Try to find pieces with the same or similar thickness, to make the process of putting the pieces back simpler.

You may also try to find a piece with a similar curvature as the missing piece, though it may not always be necessary.

Start in the center. It will give you more to grip as you are working.

Fill and chips or crevices as you are working.

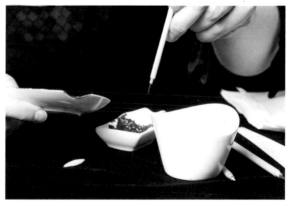

Larger plates need more support than smaller ones.

Note that in every case, pieces are not dishwasher safe and can fall apart with both heat and water pressure. If you are repairing the vessels of others or selling pieces as art, be certain to give care instructions along with your repaired pieces.

VASE RECONSTRUCTION

Unlike the other vessels, vases are not used to serve food, yet they have their own unique property to consider: they are often used to hold plants and will have *water* in them, perhaps on a daily basis.

Here, like we have seen with chalice restoration, we are concerned with filling gaps. We must test-run our vessel to ensure that it does not have a slow—or fast—leak.

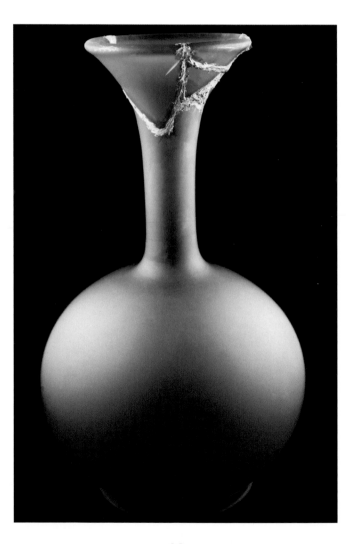

Because vases come in many shapes, sizes, and thicknesses, the nature of the repair will be different for each. Some pieces will be as simple as filling a chip, while others will involve repairing pieces in chunks. Many vases are large and must be completed in smaller sets before putting them together.

If the vase is broken at the bottom, determine if you can repair it by using the crack method, or if it will require the joint call method.

If you have many broken pieces, consider dividing your piece in groupings to be secured and dried separately before putting the dried pieces together.

Begin at the bottom. Create a base to work with, radiating out to the top.

Put the middle pieces together separately.

If there is a stem, you may need to use the piece method to fill in any missing pieces. Vases may shatter in certain areas, making the pieces too small to work with as well.

Dry each section separately.

After the first muro drying, attach the pieces together. More crevices and missing pieces may show up. Fill them with the piece or the joint call method.

Dry the vase once again.

Complete a water test. Fill in anything that has not been covered.

Dry the piece and run the test once more. Test the vessel one more time by pouring in water and waiting for an hour. If there are no leaks, continue to the next step. If there are leaks, mark them and then use tonoko powder to fill any remaining gaps. Retest your vessel after drying until you are satisfied with its soundness.

Lacquer your piece and sprinkle on metallic powder. Here, it is not necessary to use "edible" powder.

Let the vase dry one more time.

CERAMIC SPOON, LADLE, OR SPATULA RECONSTRUCTION

Like other object that contain liquid, a ceramic spoon or ladle intended to be used to pour liquid will need the same water test as other objects. Ensure that you are using gold powder and not a substitute. If you are not planning on using the spoon for serving, you can skip the water test or using "edible" gold powder.

In the case of a spatula, a "stress test" may be needed to see if it can carry the weight.

TEA KETTLE OR CREAMER RECONSTRUCTION

Ceramic tea kettles or creamers with spouts can be repaired, even if the spout has been broken off the rest of the piece. Extra care at the base of the spout will ensure there is no leakage when your piece is complete. The water test in this case will require you to pour and then check for seepage from the base. You may require tonoko powder to fill in any cracks that could cause any pouring problems.

You will require gold powder that can be used for serving food or drink, unless the piece is intended for decorative purposes only.

USING KINTSUGI AS ART THERAPY

Many art therapists are seeking additional methods of using art to help others heal, and kintsugi is an ideal vehicle to bring peace and self-understanding. At this point, you have enough mastery of the foundations to use kintsugi as a tool in art therapy, and here are a few key points to keep in mind. Professional art therapists know these principles, but even if you aren't a professional, these basics may help you use kintsugi in a more casual setting to assist people's well-being.

First, artistic and practical considerations are secondary to the therapeutic: it is more important to complete the project than to fret about potential leakage.

The point is to boost confidence and not make participants feel inadequate and unable to complete their projects. Have a variety of ceramics to choose from, preferably whole, so that part of the catharsis is having individuals break their own ceramic to put it back together. Have more vessels than participants, so no one feels as if they received something no one else wanted.

Have small objects that are straightforward to repair. If cost is a factor, choose the project carefully: use small vases or plates that are not likely to be used for food display. Inexpensive ceramics can be found in various places, from thrift stores to the "as is" section in retailers such as IKEA, but

"dollar store" items are a poor choice since shattered plates tend to turn to dust. If uniformity of items is important, considering buying in bulk. If individuality is the focus, garage sales and flea markets often may be a good source.

Be certain to have everything prepared ahead of time to underline the concept you wish to explore. The work is symbolic and therapeutic at once. If the purpose is to express pulling oneself together in order to find beauty in scars, a simple crack method approach underlines the theme. If the theme is about self-improvement and incorporating new elements in one's life as we let go of the old, the joint call method of adding new pieces is better suited, particularly if the new pieces look starkly different in color, texture, or pattern. Finally, if the theme is about creating your own personal change with your own resources, the piece method supports this notion the best.

Help your group or individual understand the concept and history of kintsugi. Create a relaxing but not patronizing atmosphere. Explain the concept of wabi-sabi and how kintsugi shows us how to embrace imperfections. Emphasize how the art began when the vessel's scars were hidden.

There should be a sense of accomplishment and bonding with the object. Do not rush anyone, and keep participants focused on the notion of rebirth and reinventing oneself despite the past.

The muro technique is a powerful symbol of metamorphosis, and it is worth drawing comparisons to a caterpillar forming a cocoon in order for it to slowly transform into a butterfly naturally. The muro box or cabinet serves the same function, and every aspect of kintsugi is organically geared toward the notion of rebirth.

Alternately, instead of reconstructing a vessel, you may wish for participants to create a pendant-form kintsugi from broken ceramics, glass fusion, or semiprecious stone.

However you decide to create your session, be mindful of the message, and how the art will create new habits of thought in people. They are there to heal, and kintsugi's message is precisely that.

Now that we have mastered the fundamentals of kintsugi, we can begin to explore nontraditional and more complex methods, not only to restore other kinds of objects such as statues, spoons, and even ostrich eggs but also to create original art with kintsugi.

PART 3:

Advanced Kintsugi

CHAPTER 8:

Exploring Kintsugi

Until now, we have looked at the ways of traditional kintsugi. We have stayed within the boundaries of the art in its purest form in terms of purpose, methods, and materials; however, kintsugi can be expanded and can offer an artist endless possibilities. Let us look at repairing more unusual items before moving toward its place in fine arts. Chapter 9 will be dedicated to using kintsugi in jewelry making and metalworking. Chapter 10 will add *maki-e* to the mix, while the final chapter shows how to use kintsugi in multimedia projects.

But before we use kintsugi for original work, let's look at how to repair other objects with it.

REPAIRING STATUES WITH KINTSUGI

While kintsugi was originally envisioned to repair pottery and simple items, it is a versatile way of repairing or reinventing other objects, and perhaps the most rewarding of these objects is the statue. Statues, like other objects, break, and they often cannot be salvaged with gluing the pieces back together. Some statues are part of a set, and it pains us to lose one of a collection. Sometimes it is one we made or has sentimental value to us, but then there are expensive statues that are large and are centerpieces of our decor. While traditional sense would have us try to hide the breakage or rid ourselves of its destruction, kintsugi provides a chance to set a piece apart by flaunting its fractures in a stunning way.

We have several options with statue repair: we can use any sort of metallic powder without worrying about ingesting the metal, but if we wish to add value to a once-valuable piece, we can use real gold to repair it. We are not even confined to gold: often, copper or silver powder has a more striking look to it. Finally, we may wish for a hint of vein or can go with a more rustic and coarser look.

If you have pieces that are missing, you may wish to fill in gaps with a tonoko mixture; alternately,

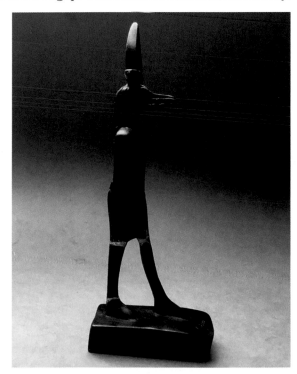

you may find other objects, such as semiprecious stones, to be more dramatic and practical. We can add texture to a statue or even decide to paint certain parts to alter the statue's look. We have the option to do a straight repair or transform the statue into something different.

To keep a statue in its current form, follow the same steps as you would any other piece.

You will need to start at the base of the statue, using painter's tape to keep it balanced. You may also wish to repair in smaller segments, drying each section before putting the larger sections together.

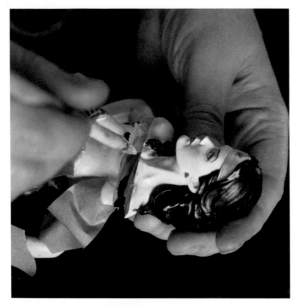

Ensure your pieces are aligned. This is important so that there is balance and the piece will not tip over. Take your time to make certain the statue is stabilized.

Plug any missing areas with filler. While it is possible to use a joint call method with porcelain or other ceramics, you may be required to file or cut pieces to fit in.

Once your piece has finished its initial drying, do a balance test to ensure it is stable. You may need to add weight by adding filler or filing any overlapping pieces.

Add lacquer and gold powder when you are satisfied with your piece.

However, if you wish to alter the way the statue looks, you have several options.

If there are scratches and nicks, you can opt to repaint the entire piece. Paint the pieces prior to reconstructing them. Let them dry before continuing.

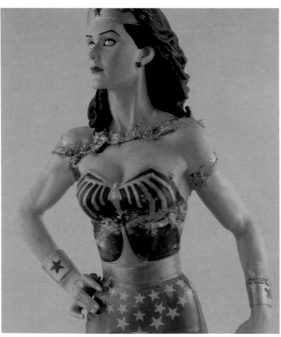

Decide if you wish to add semiprecious stones to your work. In later chapters, we will see how metal, mesh, or resin can be substituted for missing pieces.

Assemble your piece from the base upward.

Once it is dried and balanced, add lacquer to the seams and use gold or other metallic dust.

Let dry.

You may not be able to place the piece in a regular muro box. You may wish to make a cabinet instead or find a box that is large enough to hold the statue upright.

REPAIRING SPHERICAL OBJECTS

There are times when an object is a specific distinctive shape; for example, often we have glass globes that fall and break. There may be shattered fragments too small to reconstruct, but when we are dealing with geometric objects, we may wish to think how to substitute other pieces, or whether we wish to preserve the original shape or incorporate another element into it.

If you are making a simple repair, you will need to balance the object in such a way that you can work it. If it is a sphere, it will roll around a flat surface, making it harder to work with.

In that case, you may wish to substitute a flat surface with one with coarse stones to keep it in place.

Be sure that the dust or pieces do not get attached to the object while you are repairing it.

If the globe is attached by some support, and your breakage is there, test that it can be secured after the initial drying.

You may need to file a hole or use filler to ensure it is secure.

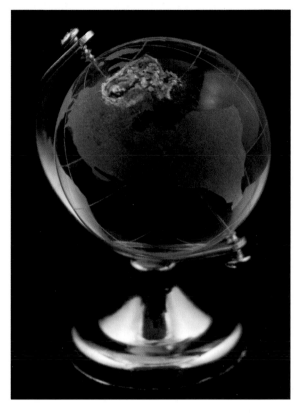

Spherical objects may require their own stand after drying, or you may need to file the bottom to ensure it stays in place.

REPAIRING CERAMIC WALL HANGINGS

Unlike most other repairs, ceramic pictures are at the mercy of gravity. They will be hung on a wall, and if the piece is not secured properly with adhesive, it can fall apart and shatter on the ground. You will require a "stress test": a simple method is to hang the piece in a wooden box, where the pieces do not have far to fall. After the piece has dried in the muro box for the final time, check the piece for its sturdiness before hanging it for a week in your test area. If the piece remains secure, then hang it as before. If you are not entirely confident, an easel to display it is a viable alternative.

REPAIRING GLASS FUSION

Glass fusion is a versatile art form, and you can use kintsugi not only to repair broken pieces but to deliberately break the piece to incorporate kintsugi into it by design.

If you wish to add kintsugi to a pendant or picture, you may wish to break the piece or use a glass cutter to strategically separate pieces, adding semiprecious or precious stones as well.

Kintsugi is a handy way to fuse back together broken lamp-working beads, as we will see in the following chapter. It is also possible to use the lacquer and gold powder to incorporate maki-e as well as kintsugi even lamp-worked beads or pendants.

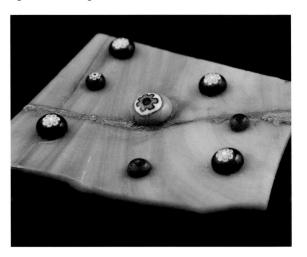

If you are using millefiori in your work, you can embed these pieces in the urushi to create stunning effects and texture.

You can create glass fusion pieces in order to break them and put them back with kintsugi. If this is your intent, you may wish to create a piece with colors or textures that lend themselves to enhance the effect of the metallic veins you plan to create.

REPAIRING ORGANIC OBJECTS

Kintsugi is not limited to pottery or fine china. We can kintsugi organic objects, such as wood, but we are not confined to the obvious by any stretch of the imagination, and with kintsugi, it can easily mesh with the most elastic of creative minds. Kintsugi is more than the celebration of scars: often those scars come from the bravery of failed experimentation. Wabi-sabi guides us to let go of confines; hence, the natural progression of the art is to break down barriers before rebuilding them with gold.

For example, ostrich eggs are large and their shells are thick enough to give us a workable surface; however, even regular chicken eggs can be put together with kintsugi. Yet, ostrich eggs, while not as delicate, are versatile and less likely to break when handled. We can paint them and use other media to create unique works.

If you are buying fresh ostrich eggs, you will need a drill to remove the yoke, since this variety of eggs has a thick shell. Drain the yoke and be aware that they are perfectly edible, and that one egg is an equivalent of a dozen regular-size eggs.

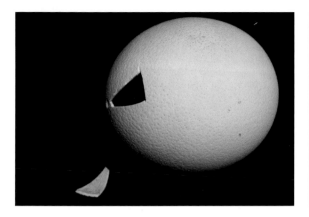

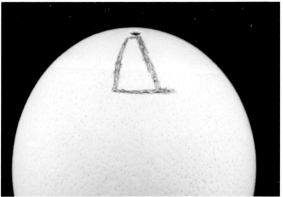

It will take force to break the shell, but once you do, you follow the same procedure as regular kintsugi, and it is recommended to use a coarser surface to balance your work in progress.

Pearls are also prime, but small pieces that can be repaired with kintsugi, and the effects can be dramatic. While pearls can be of a variety of shapes, sizes, and grades, even a lower-grade pearl can be made more valuable if it is repaired with gold.

If you plan to string the pearls or wire them, be sure that your original holes do not get clogged with the mixture, by threading a waxed silk thread to dry them, tugging gently at intermittent times throughout the drying process so that the pieces do not become glued to the thread.

BREAKING PIECES

Kintsugi was envisioned as an art to restore what was accidentally broken, and yet, to gain mastery, an artist must deliberately *break* pieces to practice putting them back together. But even during the practice phase, you will have discovered that different methods result in different kinds of breakage—and the knowledge can be crucial in creating original art work through the joint call method.

For example, breaking pieces with a hammer or mallet gives more control—but using a jeweler's chasing or planishing hammer, which is lighter than a regular hammer, breaks a smaller area than a sledge hammer, for instance. Learning to control how you break pieces can save time and extra work.

Using nippers or a glass-and-tile cutter can also "persuade" pieces to break where you need them. You may wish to buy the same make of plates in various colors, breaking them strategically. While throwing breakables on a tile floor or against a wall can be cathartic, the breakage is less predictable, and while that may work in many cases, it is not as efficient as guiding breaks.

Use a paper bag or a towel to prevent shards from turning into shrapnel.

Rotary tools or saws may be helpful, but remember that the pieces will be hot to the touch immediately after cutting them, and there may be times that a piece will shatter as a result of the heat or pressure.

You may need to file down pieces to make them an easier fit. Using a marker to guide your cuts is advisable, but pieces often may break in weak areas despite your best planning.

The beauty of kintsugi is letting go of our need to control and predict; often, some of your best work will arrive from the errors than from your best plans.

MELDING DIFFERENT CERAMICS

It is possible to mix glass with porcelain when using the joint call method. It is possible to use semiprecious stones with ceramics. We are not tethered by media, and when you are reconstructing a piece but are missing a fragment, remember that it is not necessary to stick with the identical material. Keeping a box of larger shards from other broken items, from glass to tiles, will give you more options when you have a hard-to-fit space that you need or wish to fill.

Keep in mind that pieces should be roughly the same thickness to keep the piece more secure and stable. It is not always necessary, but be aware that thicker pieces will stick out, and thinner

fragments will not be flush with the piece. You may wish for a more organic and textured look, but it is not always possible to use delicate pieces on thicker pottery, since the weight my cause the more fragile piece to break under the pressure.

It is important to plan your piece before beginning to rebuild, since there are multiple considerations to make. Fine china that is broken may have hairline fractures that will break with the slightest heat, for instance. Consider the pros and cons of any outside pieces before proceeding, to ensure that your work endures as you envisioned it.

OFFSETTING PIECES

If you are moving away from traditional kintsugi, it is possible to "offset" your pieces for dramatic effect. This may involve filing or cutting pieces of their sharp edges, to prevent cuts and to ensure balance. If you seek to keep holes, be certain that the hole will not cause a collapse of your work or cause it to become wobbly or unstable.

File the piece that you wish to use but want to be offset.

Determine in which direction the piece will be placed.

It may be a pinwheel look.

Or an "open door" effect.

Or you may wish to build depth with multiple fragments.

You can also incorporate larger pieces at the edges to create texture and visual unpredictability. Remember, patterns and textures do not need to match the original piece.

There are other configurations, but it may be necessary to conduct a stress test after the initial drying.

Alternately, you may wish to use air-drying clay, such as paper or cork clay, to build a prototype of your piece first. This gives you a model to test and follow, finding potential flaws or weaknesses before you begin.

If you are planning to paint fragments, a prototype can give you feedback before painting prior to reconstructing a piece.

MAKING ART WITH KINTSUGI

Thus far, we have focused on re-creating and reconstructing already-made work, most likely work from other artists, factories, or Mother Nature herself. Yet, we are not confined by any other of those categories. We can create *original* work with kintsugi. Unlike the restorative properties of kintsugi, there is another side to it that we can explore without deviating from its guiding philosophy. Wabi-sabi inspires us to embrace our scars of failure, but we can turn the idea around to *anticipate* scars and *create* them by design. We can push the boundaries without fear because the end goal is to create textured beauty. We are in control of our scars, and they are the goal. We are not victims, but heroes guided by our sense of adventure.

In the next few chapters, we will explore a different side of kintsugi—one where we turn over the rules to create one-of-a kind pieces that were made to be fractured in the first place.

CHAPTER 9:

Making Jewelry

Kintsugi is a versatile method of fusing broken pieces, but it is often seen as a reactive art, not a proactive one. We must deal with loss and work through the process of putting the pieces back together; yet, there is nothing to prevent us from breaking pieces by design to put them together in novel ways. In this chapter, we will explore how kintsugi need not be confined to pottery or our dinnerware but can be used in the wearable arts.

Jewelry design is an ideal place to practice nontraditional kintsugi. We are working with smaller materials and can practice using a small subset of broken pieces. If we are creating a jewelry line, we have a similar base yet can still create one-of-a-kind pieces that offer something unique but still maintain a line's central theme.

You may repair pieces such as brooches and pendants with kintsugi, but you can also use the techniques as part of the original design. Your options are limitless, and kintsugi allows for experimentation and expression, far more than what has been traditionally assumed. While this chapter cannot show all the ways to create wearable art with kintsugi, the following will get you oriented with how to make the most of it by using traditional techniques, while not falling back on faux kintsugi.

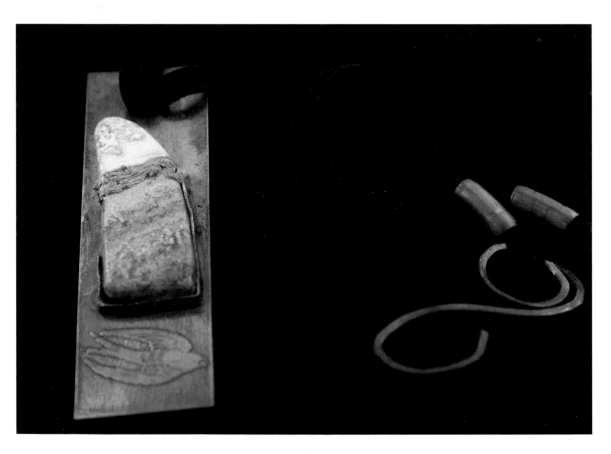

BROKEN STONE PENDANT

Semiprecious stones such as Persian turquoise, lapis, jade, druzy, and onyx are ideal to use with gold fusing. Flat beads, donut-shaped beads, and cabochons work the best, though they are not the only shapes that lend themselves to it. Larger stones work better than smaller ones. You may have several stones you wish to kintsugi, or one as a centerpiece.

If you cut your own stones, the ones you broke can have new life, either through the crack method of restoration, the piece method of having a larger swath of gold, or the joint call method of adding other stones or materials. You can also cut your stones strategically to piece them together.

If you are restoring a cabochon, you can file or use a rotary tool to create larger holes to fill with tonoko powder mixture for a more dramatic effect.

You can also use pieces to frame another stone into your work through the joint call method.

To create a pendant by using two different stones, take two similar-sized cabochons. Use a rotary tool to cut them in half. The stones will become hot. Take your time, or if you are familiar with stonecutting, submerse them in water to cut them.

Meld the pieces together. Let dry.

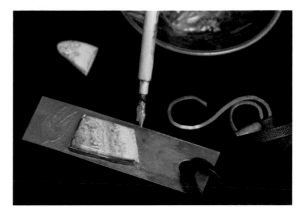

Wire the piece or create a bezel to nest it.

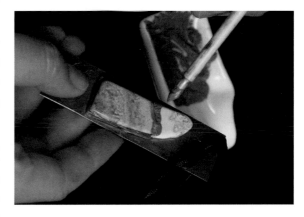

If you are creating a large pendant from the stone, you may wish to conduct a "stress test" after the final drying. Simply hang the pendant on a piece of string and hang it on a stand on a table with a towel. If gravity doesn't cause the piece to fall apart after a week, it is ready to wear.

BROKEN GLASS FUSION BROOCH

Glass fusion is a popular method of making pendants and brooches, and we can easily incorporate kintsugi in a number of ways. Many glass fusion pieces break after being crushed or dropped, giving an artist a way to salvaging the piece while adding value to it. Other times, the kiln process was not followed properly, and weaknesses in the glass cause breakage later on. In either case, we can repair the piece, or we can break pieces in order to put the pieces back in novel configurations.

If your piece of fused glass has a chip, tonoko powder mixed with urushi and rice glue will still work. Alternatively, if you wish to add chips to your piece to break, you can use a glass etchant to "bite" the glass.

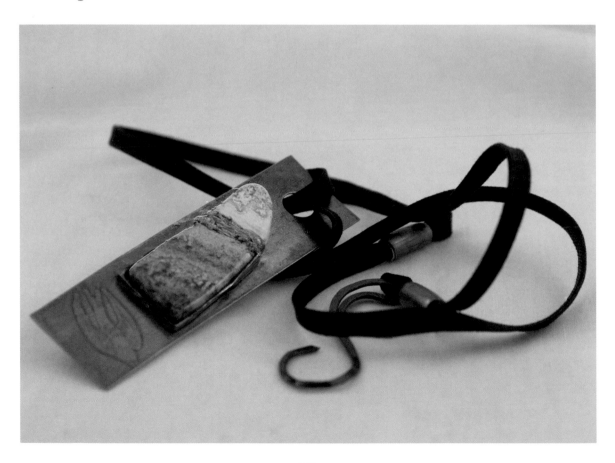

Use painter's tape to cover what you do not want to be etched. Keep what you wish to be etched uncovered.

Pour the etchant in a plastic container.

Immerse the piece in the solution. The longer it is in the etchant, the more "bite" it will have.

Keep checking on the piece until it has eroded to your desired depth.

Remove the piece and wash it. Remove the tape. Return the etchant into its original container, since it can be reused.

Follow the same steps as you would to fill a dent.

Let the piece dry.

Remove it from the muro box and add lacquer and gold powder, removing any excess with a cotton swab.

Return to the box to dry.

You can also break your fused glass and use any kintsugi method to put the pieces together. You can add other materials in a joint call method, such as semiprecious stones or ceramics. You may choose a piece method of creating a piece. They do not have to fit perfectly and can be fused together in any sort of configuration of your choice.

If you are creating a brooch, glue or wire a pin in the back of your piece.

You may also wish to add a metal backing to your pendant or brooch. If you do, be sure the metal blank has a hole or loop for your piece to be worn as a pendant, or a pin in the back if it is to be worn as a brooch.

LAMPWORK AND KINTSUGI

Similar to glass fusion is lampworking, a process of melting glass rods onto a metal mandrel and then annealing the pieces in a kiln. For many novices, removing the beads off the mandrel causes breakage, meaning there is a weakness in the beads, such as an air bubble, and repairing the piece will not fix it. If the bead breaks in half for other reasons, you can repair it with kintsugi. However, other times, the beads break if dropped, and kintsugi can restore them.

But you can also use glass etchant to create patterns and crevices to fuse with gold, adding a novel layer to the bead. It is recommended that you remove the bead from the mandrel first, since a broken bead has other weaknesses that will make it break further.

Like glass fusion, if you are intending to create pieces to be broken and repaired, consider the patterns and textures as you are making the bead. Adding depth and complexity may not be entirely predictable or a process where you have full control over the results, but with practice, you can create unique pieces with a uniformed flow—or deliberate dynamic tension to surprise and intrigue.

KINTSUGI RINGS AND EARRINGS

If you have smaller fragments of stones, glass, or pottery, it is entirely possible to use kintsugi to create earrings and rings, using any of the traditional methods.

If you are making a ring, you will need to create a cradle or bezel to place the piece inside.

Once your kintsugi "stone" is created, place it on a sheet of metal. Copper, silver, or bronze is ideal. Copper is cost effective and easy to work with, but it tarnishes. Silver is a pricier choice that also tarnishes, but it is also easy to handle. Bronze is a cost-effective metal that is slow to tarnish, but it is harder to work with. For this project, silver is the metal of choice.

Use a marker to trace around your piece. Remove the stone and use shears or a rotary tool to cut around your metal.

File your piece of metal.

Cut a narrow strip to go around your stone.

Shape the piece to cover the entire side of your stone.

Place the formed metal on top of the base. File any rough edges. Place the stone inside to ensure a snug fit. Remove the stone.

Place your two pieces on a soldering board. Use medium silver solder and flux to attach the pieces.

Place your piece in pickle (Sparex No. 2, for example) to remove impurities.

Cut around the strip of metal to go around your finger.

Form the piece of a metal mandrel, hammering it until it is formed. File any rough edges.

Solder the piece to the back of your cradle and place it in pickle.

Clean the ring, and drop the kintsugi stone inside. You may wish to glue the piece inside and press in the bezel for a snug fit.

For earrings, you can use a jump ring and wire to attach the piece to the earring hook.

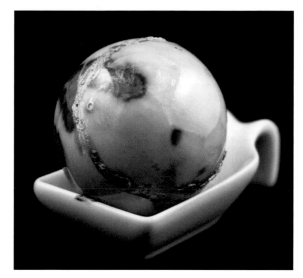

There are more complicated methods of creating rings and earrings, and the advanced metalworker can treat any kintsugi piece the same way they treat stones and beads. Beads can be created using kintsugi, forming a sphere instead of a flat piece.

Create the sphere or cube bead by creating sections, drying each individually before placing them as a single piece. This will be a long process, and you will need to force and form pieces into place. Patience is required.

Use a mandrel to create a hole around the formed bead.

Dry the piece with the mandrel and remove it once it is dried.

Now that we have mastered smaller objects to create original pieces, let us move on to larger art pieces.

CHAPTER 10:
Maki-e and Kintsugi

So far, we have created pieces to restore, keeping the base untouched, but we can turn ceramics and glass into a canvas to add depth and texture to our work and transform our pieces into bolder statements with a more personal touch. We can paint a single fragment, paint two, or paint all with the same pattern or different ones. We can paint a scene or a pattern. The pieces can be constructed as originally created, or we can create sculptures in any sort of configuration. The freedom that kintsugi allows us shows us the limitless potential of those broken pieces. Scars and flaws are to be celebrated for a reason. A clean slate—tabula rasa—has its place, but so does a palimpsest—the paper of monks who *rewrote* over scarce paper since they did not have clear sheets at their disposal.

Kintsugi teaches us that there are no obstacles to beauty and creativity. Let's look at using materials we have already used, to push the boundaries of this ancient art form.

PAINTING WITH URUSHI

Urushi is a lacquer and was in use long before the advent of kintsugi. Since it predates kintsugi, if you wish to add more authentic twists, painting with urushi is a fine way to do it.

You will need the same sort of kebo paintbrushes, and these come in a variety of sizes but are known for their fineness. Whether you choose to paint a solid color, or a scene or portrait, you have a variety of urushi colors available.

The lacquer is thick and not always simple to work with. The painting will take weeks to dry, even when using a muro box or cabinet. You may wish to use traditional Japanese scenery or patterns, or go a contemporary route.

You may wish to paint and dry your pieces prior to assembly, or you can wait until the piece is assembled; however, if you are using gold dust and do not have full control, you may wish to assemble and dry your piece before painting it.

Paint slowly, ensuring that your lacquer is not applied too thickly, or else it will take longer to dry. Apply a small amount of lacquer at a time.

You may wish to sketch your design on the ceramic, or you may use a projector to impose your sketch onto the piece. It is possible to use a stencil, but avoid smearing the lacquer when applying it or lifting the stencil.

Let dry in a muro box. You may wish to retouch or add to your work, and you can do it at any time during or after the drying process.

MAKI-E AND KINTSUGI

Maki-e is a Japanese art of using urushi and gold dust to create paintings and is most closely associated with wood items, particularly painting on wood-turned pens. The process of maki-e is nearly identical to painting with just lacquer, except for sprinkling dust on to the lacquer. The extra step takes extra care, since gold dust can become affixed to any painted piece you wish to remain untouched. Use a kebo brush to paint your piece.

Decide on your pattern or scenery and then sketch it onto your ceramics.

Decide which parts are to be fused with gold. You have several options here. You can paint those parts first and infuse the lacquer with metallic dust. Let dry before painting with lacquer, to be left to dry on its own.

You can also repeat the same method but paint the secondary parts while the infused parts are still wet.

You can incorporate any other elements you choose, from wire mesh to glass fusion. Urushi is an opulent lacquer with deep and rich hues and can add stunning details to your work. Like oil paints, it takes a long time to dry, but increasing the humidity of the enclosed area can speed the process.

USING CRACKS TO EXPAND ARTISTIC MESSAGES

Often overlooked, the cracks we fill with gold can be used in novel ways. We can include them in artistic details, such as turning the cracks into branches, vines, or waves.

For example, we can *open* cracks in order to place objects inside them, such as millefiori, cabochons, or metal clay pieces. If the piece is small enough and we prefer a textured piece, we can simply drop the piece on top of the mixture of urushi and rice glue; however, if we want the piece to be flush with the rest of the piece, there are a few steps we can take.

Before starting, take the pieces that will frame the extra piece, and fit them together. Use painter's tape to secure them.

Use a marker to mark the spot where you wish to place the piece.

Use a drill or rotary tool to carefully chip away the piece. Wear safety goggles to prevent any flyaway pieces from hitting your eyes.

Retape the area and test to see if your piece fits. You may need to file or sand the area to make it fit.

Remove the tape and begin to assemble your piece with urushi or tonoko powder mixture, or both.

Add the extra piece and use painter's tape to secure it.

When you are finished, place in the muro box to dry.

With the piece method, we replace one fragment with a substitute. If we wish to expand the cracks, we are essentially using the same method but seek more control over the veins of our vessel.

We can also expand our cracks by filing or sanding them and then using a tonoko powder mixture to form flowing patterns. We can control the direction and shape to create a centerpiece. If a piece had broken in half, we can open a larger hole between the two halves to add mesh or metal sheeting that has been chased, forged, or etched.

We can have a larger control over the veins and cracks to create waves or patterns as we incorporate those veins with the urushi lacquer. We can create pieces that are unrecognizable from their original form, and bring a distinctive style to our work.

WHEN OTHER OBJECTS ARE ATTACHED TO A PIECE TO BE RESTORED

Sometimes, repairs are more delicate and compli-cated than meets the eye. For instance, a sentimental piece has broken, but it is part of a larger object that is required to be kept in place, since the broken part cannot be repaired separately. For example, a broken ceramic bead in a macramé holder may be a rarity these days, but you cannot repair the bead unless you have it attached to the braid.

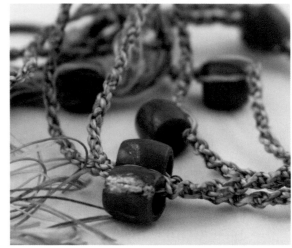

In cases where your repair will have a small working space and confine your options, it is important to keep the integrity of the central object, even if you are re-creating the broken piece. You will need to take care that urushi does not stain fibers, for instance. The piece must rest in its natural position.

Ensure that any fibers are protected with plastics or painter's tape. Ensure that whatever barrier you use does not cause additional damage to the central piece.

Take a look at the area where the broken piece is to be restored. Test to see how you will place the object back in its original place.

Ensure that the central object can be exposed for prolonged periods in a high-humidity environment. You may have to cover the object with a protective barrier and check on it frequently. Ensure that your box or cabinet is large enough to store the object without further damage.

Repair the piece, taking care not to get any rice glue or urushi on any fibrous area.

Let the piece dry and cure in the muro box.

Ensure that the piece is placed back properly. Use lacquer and gold to complete the piece. You may wish to use maki-e to beautify a piece as well.

Place it back in the box to cure.

Remove the extra powder and remove the barrier used to product the central piece.

Before we conclude our journey into the most therapeutic of the arts, let us explore incorporating metalworking and other kinds of paints into our pieces.

CHAPTER 11:

Multimedia Kintsugi

The versatility of kintsugi allows us the freedom to create surprises within our work: we can break various media in order to explore the world of imperfections. If to err is human, then exploring that very human realm can open new worlds of expression and understanding. While much of art focuses on refinement and perfection, kintsugi opens the world that many try to hide from or feel shame about. Yet, as we have seen throughout the book, broken doesn't mean feeble, weak, wasted, defective, or ugly. We learn to refocus and reinterpret our perceptions to see our world in a new way. We do not discard; we revise and rework. We do not waste our resources; we merely learn to look closer for their purpose as we rebuild.

Kintsugi is more than an art of repair. As we have seen, it can create original art as well. For those who wish to find beauty in the ruins, there is as much to find as there is in the pristine. We do not merely come to accept the rubble, however. We take those pieces and put them back together. Each piece speaks to us, and sometimes they do not wish to be put back together in the same way they were intended. They break free from the confines of the past and develop their own distinct personality. Kintsugi teaches us more than just unity, but also individuality. A single piece from a broken vase may make more sense being the sole colorful piece of a restored bowl. That is the power of kintsugi: it breaks the barriers of a seemingly single unit and shows that it is, in fact, a part of something else.

Once we grasp the significance of that truth, we are free to add our own individuality to our works. In that spirit, let us take a look at other ways to enhance the concept of unexpected individuality by using alcohol inks and metalworking, as well as incorporating kintsugi with its spiritual twin, picassiette.

Here are a few starting points as you consider taking your kintsugi work in new directions.

ALCOHOL INKS: SOME WAYS TO EXPLORE

If we are working with plain ceramics, we have interesting options when we are restoring a piece in order to re-create it. While the piece method allows us to incorporate different pieces, and maki-e allows to paint over them, they are not the only ways of creating diverse pieces within a single vessel. We can also use alcohol inks in order to achieve both a common theme and diversity with each piece.

We have several options: we can use alcohol inks on the whole vessel before breaking it, we can use it on the restored piece, or we can shatter and then ink one, more than one, or all the pieces differently to create a more visually complex piece.

In any case, if you are inking your pieces, you cannot use them to serve food or drink.

To use alcohol inks on ceramics, glass, or porcelain, you will need colored alcohol inks as well as the clear alcohol as a bleeding medium. It is not necessary to purchase bleeding solutions, since rubbing alcohol can be purchased at any drugstore at a lower price. Alcohol that comes in spray bottles is particularly handy for this purpose.

BASIC HOW TO

- Clean your pieces with rubbing alcohol and wipe clean. This ensures that no oil, dust, or fingerprints are left on your piece.

- Spray one piece to cover it with rubbing alcohol. Make sure it is thoroughly covered, since alcohol evaporates.

- Take one of your color inks and drip it on your piece. You can be as frugal or generous with this as you wish.

- You can use multiple colors on a single piece.

- You can also drip clear alcohol to add depth.

- Let the pieces dry when you are finished.

- Use a sealant to spray your pieces to keep the color. Let each coat dry before spraying it again. Keep the spray several inches away from the piece. Spray outside or in a well-ventilated area. Wear a mask.

- Do not wash or dishwash your work or the colors will wash off.

Use any method of kintsugi to assemble the pieces. When you are placing the vessel in a muro box, add a plastic barrier to the towel. You may wish to forego the humidity for your piece if you are uncertain.

You are not limited to urushi or alcohol inks. Glass paint and other kinds of paints will work to create vibrancy or depth to your pieces. You can use matte black opaque paint to create a solid ancient look, or translucent paints to mimic a stained-glass look.

You can create layers with any number of media to transform pieces to express whatever you desire.

METALWORKING AND KINTSUGI: SOME WAYS TO EXPLORE

We have seen a smaller version of this combination with jewelry making; however, kintsugi and metalwork are a natural fit. Like ceramics, metal lends itself to alcohol inking, and to etching, meaning we can mimic veins of our vessel to seemingly flow onto metal.

While it is beyond the scope of this book to show all the ways that metalwork and kintsugi can be used together, we can use metal rods and sheeting to create dramatic pieces and transform vessels into bold works of art.

- If you are using metal rods or strips, they can be embedded between pieces.

- Take a rod and sandwich it between the two pieces you wish to use. You can mark the piece where you wish the rod to be placed, and then file both sides down to create a snug cradle for the rod.

- Use the methods of kintsugi to glue the pieces together. You may need a vise to keep the pieces together without the rod slipping.

- If you opt to use metal sheeting, you can chase and forge pieces and wrap them around parts of your work. If you are planning any soldering, it is advisable to do it before adding your ceramic pieces, since the heat will cause the adhesive to melt and the pieces to break. While there are coolants for gems that can be applied, they cannot protect the adhesives, and it is recommended not to do it in this fashion.

- If you choose to enamel the metal, it is advisable to do so prior to setting your kintsugi piece, for the same reason. The setting of the piece should be the final step of the process.

CREATING LARGER WORKS WITH KINTSUGI: SOME WAYS TO EXPLORE

It is entirely possible to create larger pictures and sculptures with kintsugi. If you wish to create a picture, you may wish to reinforce the back with metal for support. Sculptures are also possible, using broken pieces to create larger works.

- If you are creating a kintsugi sculpture for the first time, you may wish to create a Styrofoam or paper clay form as a guide to rest your pieces against them, using painter's tape to secure pieces together.

- You may begin at the base and then dry it in sections, waiting for a previous section to dry before working on the next section. This process may take months, depending on the size and complexity of your work.

- For very large pieces, you may need metal rods and supports to keep the piece balanced.

PICASSIETTE AND KINTSUGI: SOME WAYS TO EXPLORE

There is much in common with picassiette and kintsugi, since both work with broken ceramics. The main difference is that picassiette is a form of mosaics that uses grout and has European origins; however, both can be used together to create novel pieces.

- If you are forming a base, you may wish to use picassiette at the bottom and then use the same pieces to build a kintsugi-based sculpture or vessel.

- Alternately, you can use urushi in lieu of grout to create a fusion of the two forms.

Conclusion

A Few Final Thoughts on Taking Kintsugi to the Next Level

This guide has provided a small sampling of what you can do with kintsugi techniques: this a starting point, and there are countless permutations that will give you a new tool in your artist's repertoire. Finding new methods of expression by revisiting ancient techniques allows an artist to weave the past, present, and future together, and kintsugi is an ideal medium to do it. Whether you are merely repairing a sentimental candleholder, an art therapist seeking a more symbolic way to heal patients, an artist looking for a new way to express your gifts, or someone at a crossroads wanting to find a form of philosophical expression, kintsugi is a versatile art that is far more than what it first appears. It has not been explored to the fullest, and its journey has been a long one, but there are new paths for us to take with it. Like the gold veins of a restored vessel, kintsugi can take us in any direction we choose to explore. It is an art with a colorful past that allows us both to soar as we turn over a new leaf with our creativity. It is a defiant art, but one of peace and restoration.

Kintsugi is about the journey as much as the destination, and it is one where every route is a golden one, no matter what happened in the past or what awaits us in the future.

References

Japanese-Language Texts:

Kuroda Yukiko. *Kintsugi o tanoshimu: Tojiki shikki taisetsu na utsuwa no naoshi-kata / The Joy of Kintsugi: Urushi Lacquer Handbook*. Tokyo: Heibonsha, 2013.

Nakamura Kunio. *Kintsugi Handbook / Kintsugi techō: Hajimete no tsukoroi*. Tokyo: Genkosha, 2017.

Ozawa Noriyo. *Kintsugi no susume: Mono o taisetsu ni suru kokoro*. Tokyo: Seibundoshinkosha, 2013.

Yamanaka Toshihiko. *Kintsugi ichinensei: Hon'urushi de yakimono garasu shikki made naoshimasu*. Tokyo: Bunkagakuenbunkashuppankyoku, 2012.

English-Language Texts:

Kempton, Beth. *Wabi Sabi: Japanese Wisdom for a Perfectly Imperfect Life*. New York: HarperCollins, 2018.

Lorenzetti, Chiara. *Kintsugi: The Art of Repairing with Gold*. Biella, Italy: Chiara Lorenzetti, 2018.

O'Shea, Colleen. "Kintsugi-Repaired Ceramics in a New England House Museum? Analysis and Western-Style Simulation." *Selected Proceedings of Advances in Conservation*, November 2017. https://epubs.utah.edu/index.php/waac/article/view/4017.

Yip, David. "Kintsugi: Loss and Rebirth." *Solitaire Magazine*, May 10, 2016. www.solitairemagazine.com/kintsugi-loss-rebirth-ancient-japanese-art/.